WORKS BY THE SAME AUTHOR.

Baldwin: Being Dialogues on Views and Aspirations. Demy 8vo, cloth, 12*s*.

Euphorion: Studies of the Antique and the Mediæval in the Renaissance. Demy 8vo, cloth, 7*s*. 6*d*.

Studies of the Eighteenth Century in Italy. Demy 8vo, cloth, 7*s*. 6*d*.

Belcaro: Being Essays on Sundry Æsthetical Questions. Crown 8vo, cloth, 5*s*.

Ottilie: An Eighteenth Century Idyl. Square 8vo, cloth, 3*s*. 6*d*.

The Prince of the Hundred Soups: A Puppet Show in Narrative. Square 8vo, cloth, 2*s*. 6*d*.

LONDON: T. FISHER UNWIN.

JUVENILIA

JUVENILIA:

BEING A SECOND SERIES OF

ESSAYS ON
SUNDRY ÆSTHETICAL
QUESTIONS

BY
VERNON LEE

VOL. I.

London
T FISHER UNWIN
26 Paternoster Square
MDCCCLXXXVII

CONTENTS.

	PAGE
Introduction: Juvenilia	1
The Lake of Charlemagne	23
Botticelli at the Villa Lemmi	77
Rococo	131
Prosaic Music and Poetic Music	149
Apollo the Fiddler	165

JUVENILIA:

TO MY FRIEND CARLO PLACCI.

JUVENILIA:

TO MY FRIEND CARLO PLACCI.

———◆———

In calling this volume "Juvenilia," I do not intend to suggest that I consider myself as already and utterly in the sere and yellow; although I may have occasionally put great store upon the abyss of years separating twenty-five from thirty, in order to obtain from you, my dear Carlo, more patience for my theories and sermonings.

My meaning is not that. Do you remember, among the allegories on the floor of Siena Cathedral, the little fifteenth-century figures representing the various ages of man? Among them is Youth: a boy holding a hawk. Now there is no reason

why a hawk should not be held equally by a man of mature age; and the good people of the Renaissance, who saw their great captains and orators and merchants and reverend signiors of various descriptions ride out a-hawking many times and oft, were certainly aware of this. But whereas to the mature man hawking is but a mere holiday pastime; to the youth it and all similar sports are the most serious matters in the world; indeed, the only matter for which a serious creature can be expected to exist. Hence the hawk is on the wrist, not of the mature man, but of the boy; though the one may bring back whole bags of partridges, and the latter but a solitary brace of sparrows.

Similarly in the case of these essays. I do not imagine that æsthetical questions are fit only for immature young people— forgive what seems a personal reflexion— nearer twenty than thirty. I mean that, in many cases, in my own case certainly, and

in yours I suspect, they are, up to a certain age, the only, or very nearly the only, questions which seem thoroughly engrossing. Later we care for them still, and perhaps fully as much; but we care for other questions also. It is the case of the boy with the hawk; and for this reason I class such matters as " Juvenilia." And, therefore, my dear Carlo, I dedicate this little volume to you, not because I conceive you to be still in the phase when only things of this sort seem important; but because, on the contrary, you appear to be emerging from that intellectual boyhood; and I would therefore fain talk with you, now that the serious interests of the soul are beginning to push aside its mere pleasant pastimes, of the relative values of these things, and of what is due to each.

You will think me, perhaps, unjust, to my own past, and to what is still your present. The Beautiful, you will say, the Beautiful thus contemptuously classified

under the head of "Juvenilia," is the beautiful not merely of material objects, but of the soul. We, who are young—and none the worse for our youth (you continue, and I agree with you)—are not mere fiddle-faddle dilettanti, adorers of roulades and Japanese lacquer and "Odes Funambulesques." We are serious; and seriously seeking for the beautiful, and for what is the same as the beautiful, the good.

I know it. In those earliest years of spiritual existence, we are far removed from every baseness. The danger of baseness, indeed, comes later, with the consciousness of imperfection and conflict, with the necessity of making a choice. Taken in themselves, those early days of thought and feeling are exquisitely calm and pure; we require their memory later, as a refuge from present reality. The only pity is that this comparative Elysium was never a reality, but only a phantom place of our own fantastic building.

It came home to me very keenly, like the taste or the scent of some fruit or flower not seen for years, the peculiar flavour, I would call it, of those æsthetic, classic, Goethian days, while reading Pater's " Marius the Epicurean." The book is to my mind the most charming, and in a way, consolatory, of any latterly written, precisely because it takes one back to those first years when the good and the beautiful seemed as the concave and the convex of all things. I read it in the earliest days of our Florentine spring. The banks were full of fennel tufts, of sage, marigolds, and all manner of herbs that leave an aromatic, spring-like scent upon one's hands; between the leafless vines the paths were powdered with daisies; on the hillsides the peach and almond blossoms made a pinkish, whitish mist upon the silvery olives, the coppery sere oaks; and everywhere in the sprouting bright green wheat, flamed the scarlet and purple anemones, the light playing with

them as with gems. The pale blue sky was washed by recent showers; the air of delicate cold crispness. With these impressions from without mingled the impressions of the book: sunny, serene, bracing, like those first spring days, with its background of the Latin country life of Virgil and Tibullus; its principal figure, harmonious and strong and chaste like the statue of some high-born boy priest; its story of the search after Beauty and Good, the Lehrjahre of an antique Wilhelm Meister; but a Wilhelm Meister simpler, purer, more dignified than the hero of Goethe. The book brought back to me, more vividly than the sunshine and daisies and scent of crushed herbs, the sense of a moral and intellectual spring; the poignant remembrance of long ago, when at eighteen or nineteen I too had read those descriptions of rustic life and rites, austere and serene, in Virgil and Tibullus; when I too had looked upon the world as a tract of spring-

tide country, through which one might wander, calm and wise, like an antique statue, in search of the great dualism: the Good and the Beautiful. The Good? One feels, at that age, that one has got it; for who can connect anything save good with beautiful form, when it is temperate, harmonious, perfect; with sensations and emotions and thoughts so utterly simple, single-hearted, and detached from all things practical? The world is beautiful, or we see only its beauty; we feel, therefore, happy; and in feeling happy (being consciously harmless), we feel also good. It is the morality of all antique art and philosophy, of the teachings of Goethe and of Plato, of every blossoming fruit tree and sprouting blade of grass; and it is the morality of the youth of such of us as are best.

Unfortunately, it is delusive, and when we come to read " Marius " a second time we feel a certain sadness, of which this book is the seemingly serene result.

Little by little we begin to perceive that there are ugly things in the world: apathy, selfishness, vice, want, and a terrible wicked logic that binds them together in thousands of vicious meshes. And perceiving the ugly things in the world, we perceive for the first time, perhaps, the ugly things within ourselves: for of each there is somewhat in each of us. Then comes the moment of choice: we have learned, or guessed, that in continuing to live only for and with the beautiful serenities of art, we are passively abetting, leaving unfought, untouched, the dreadful, messy, irritating, loathsomenesses of life; and, on the contrary, in trying to tackle even the smallest of these manifold evils, we are bringing into our existence ugliness and unrest. Gradually, in short, we discover that to be good means, unluckily, to deal with evil; to be, I will not say beautiful, but clean and moderately healthy, spiritually, means to see much that is ugly and foul. Of course

we may still go and live with the daisies and the statues, seeing only them with the eyes of body and soul; unfortunately to live with the daisies and statues means no longer to be like unto them, but like rather to the dust-heap and the scarecrow, not much more beautiful in soul, certainly.

We were happier first. Decidedly; that is what I have been insisting all along. But while we were happy other folk were wretched; and this convenient division of property and class cannot be kept up for good. I know not whether the old saints were judicious in stripping off their good clothes, amply sufficient for themselves, that beggars might have them, each rather less than he needed; nor whether the Socialists of to-day would be wise in dealing similarly with their own (or other folks') worldly possessions. But this seems certain: in order that the great mass of mankind, which has neither peace nor dignity, nor beauty of life, should obtain

a small allowance of any such qualities, it becomes necessary that we, who happen to possess thereof, should deprive ourselves of a portion for their benefit.

Hence there comes a time, to such of us as shall not remain eternally children, when, by the side of all questions artistic, there must arise other questions, less pleasant to contemplate, and less easy, alas, to solve, nay, seemingly, almost insoluble. And together with this there comes also the knowledge that such things as have hitherto absorbed our attention are "Juvenilia." How such questions arise? In a hundred ways; and less perhaps from our additional experience of the world than from a greater maturity within ourselves; for external matters would not affect us were it not for a certain change in us. Mere visible objects become something more than mere visible objects; and individual cases begin to pain us with the force of great class evils.

This, my dear Carlo, you are beginning to feel, and more so, I think, quite of late. You have just been in England, and England shows its evils grimly, as much as Italy, unconsciously, thanks to climate, beauty, and a certain dignified stagnation, hides them. Moreover, while Italy makes one think of the past; England, inevitably, leads one to speculate upon the future: each country is a key to what is not yet, or no longer, mere present. Among the various sights, I don't know whether you saw, along with theatres and slums, and political meetings, and æsthetic houses, what to me must always seem one of the most impressive of all spectacles, short of hell—the Tyne at Newcastle. Impressive spiritually as well as physically. A vast mass of leaden water, polluted with every foulness, flowing heavily, or scarce seeming to flow at all, between lines of docks and factories, their innumerable masts and innumerable chimneys faint upon the thick brown sky, faintly reddened

with an invisible sun, and streaked in various intensities of brown and grey and black, with ever rising curls of smoke. This river flows, most often as deep as in a gorge, between banks of blackish cinders, of white poisonous chemical refuse, or worst of all, of what was once pure live soil, now stained and deadened into something unnatural, whereon the very weeds refuse to grow. Down these banks trickle, from black blast furnaces, and rotting greenish docks, and white leprous chemical works, crumbling with caries, foul little streams, vague nameless oozes, choking with their blackness, staining with their deadly purple and copper-colour and green and white; while the air is thick with the smoke as of brickkilns, with the hospital whiffs of chlorine. And against this sky rise the masts and riggings, and funnels and chimneys and cranes, the long line of crumbling reddish roofs and black sheds, to where the great river, thickening and thickening in the greyness, a great river

of hell, winding in huge folds, spreads itself out at Jarrow into a grey and sullen lagoon, marked with serpentine posts, and ribbed with rafts, a Stygian lake, among the dim lines of chimneys and rigging. But sadder even where, up at Newcastle, things seem less bad: sadder where there rises sheer from the water a mound of vivid green crowned by a black church, greenness of an abandoned churchyard; making the grey of the water, the blackness of the houses and soil but the greyer and blacker, the violation of all natural things more keenly felt, with the suggestion, that but a few miles off are the brownish moors and pale green fells. And in this spot also, as if to remind us that, as there are still in the world green places, so there is also in the world's history a period when other things were held more important than the plating of ironclads, the ribs of ships, coal, coke, and magnesia, there rises above the polluted river, into the smoke suffused with sun redness, the

delicate outline of a mediæval church tower.

There are men who live among all this by the thousand, and they are far from being the worst off in the world; men like those who crowded the Tyne steamer returning home after their day's work; black, red-faced, and blistered, or with flesh in pale creases under the grime, their clothes engrained with dirt, shiny with grease, often tattered, the filthy wisp of comforter round their necks; men who sat silent and morose, scarcely exchanging a word, and who are yet human beings, intelligent and sensitive, who get treatises on political economy from the free library, in order to see why things should be so very queer and uncomfortable down here. There are other men also, not living on the Tyne, and women also, clean, well-dressed, appreciative of art and music and literature, with whom we can sympathize vastly about Wagner, and Swinburne, and Whistler,

and Venetian sunsets; for whom, in short, we write our books, sing our songs, or paint our pictures, as the case may be; men and women, of whose souls we occasionally get a glimpse, a glimpse that shows that polluted as are the waters of the Tyne, and black as are its smoke-clouds, and noisome and sterilizing its fumes and trickles of refuse, there are things more polluted and blacker still, and more noisome and sterilizing.

These things are beginning to strike you; and, therefore, you complain, you no longer feel quite so happy as formerly; no longer so certain what to think and to care for. Therefore you, also, are beginning to have a class of interests which might be called "Juvenilia."

"Juvenilia!"—Well, why not? And why not be contented with them? Have we a recipe to cure all evils? Can we clean out the Tyne, or clean our neighbours' souls? And if not, why talk or think about either; when there are things

which are clean, pleasant, and which require only that we should enjoy them : art, music, poetry, beautiful nature, delightful people ? If such things are " Juvenilia," were it not better to cast in our lot with them, and say boldly, I choose to remain young ?

Not so. For do what we will, devote ourselves exclusively to the pleasant and certain things of this life, shut our eyes and ears resolutely to the unpleasant and uncertain; we shall be made, none the less, to take part in the movement that alters the world. Help it to alter we must, in so far as each of us represents a class, a nationality, a tendency, nay, as each of us eats a certain amount of food and occupies a certain amount of standing-room. For the whole of all things is ever moving, changing plan and form; and we, its infinitesimal atoms, are determining its movements. The question therefore is, in which direction shall our grain of dust's weight be thrown ?

This is what we require to know. Do not let us swell with self-importance. It is not a question of our leading any one—you or I, or Tom, Dick, or Harry. The number of the world's leaders is small, and perhaps the world's leaders are necessarily irresponsible, biassed, blind, mere forces. It is a question of being led; and in which direction; of being led towards good or towards evil, in darkness or in light; for follow, in one way or another, with some result, of more or less comfort or misery to some one, we needs all must. Therefore, it behoves us to know what the world is; what we ourselves are; above all, what we think, and why we think it.

And therefore also, my dear Carlo, we must look at many things that are not beautiful; we must bring home to our feelings many things that are not good; we must think out many matters that are bitter and uncertain; we must recognize that we are no longer children, and that

we have other interests besides those which I have called " Juvenilia."

The feeling comes home to one often and oftener; and in less and less expected ways. It saddens, in a certain sense, and makes the world less pleasant, and one's companionships less satisfactory. But, on the other hand, it gives to the world a meaning which it never had before, this seeing it no longer as a mere storehouse of beautiful inanimate things, but as a great living mass, travailing and suffering in its onward path; and it makes one feel less isolated, in a way, to recognize all round, among creatures of different habits and views from one's own, and profoundly unconscious of one's existence, the companionship of the desire for good. Last autumn, just before that glimpse of the Tyne, I was wandering about with some friends about the foot of Cross Fell, when we came, in a tiny hamlet, upon a company of Methodist preachers. The

cluster of black cottages, with the brownish green slopes, scarcely purpled with heather, stretching away, roll after roll, without a tree or a bush for landmark, gave me a sense of remoteness greater than anything I have ever felt before; the very roads seemed to lead nowhere, and the paths to wind on, from hill-top to hill-top, with always the same clouds to face them and nothing else. In the middle of the village green, that is, of the bit of grass round the pump, with the big brownish moorland, ribbed with black walls, rising behind, a dozen people, the total of the inhabitants, were gathered round a youngish man, in a long black coat, with a wide white face, who was bellowing out the necessity of following the call of God, of coming to the light. I fear the poor man would not have thought me a very satisfactory listener; and I certainly should not have considered his views decisive as to the nature of God and of God's light. But

I felt that, in a certain way, we sympathized, he and I; and that there was a closer link between us, without two ideas or tasks in common, than between myself and so many of my friends, whose pictures I look at, whose songs I listen to, and who are so polite as to read and praise my books.

Yes, certainly; for I could have told that Methodist preacher, and he would have understood me, though he had never perhaps seen an antique, nor heard an opera, nor read a novel, what I have wished to explain to you, my dear Carlo, that there are in life "Juvenilia," but there are other things also.

THE LAKE OF CHARLEMAGNE.

AN APOLOGY OF ASSOCIATION.

THE LAKE OF CHARLEMAGNE.

AN APOLOGY OF ASSOCIATION.

A SENSE of indecision and self-contradiction has been worrying me of late. A suspicion has come to me, in moments of weariness and depression (as such suspicions always do come), that I might be getting entangled in exaggerated, unjust notions; that I might, so to speak, be selling my soul to the most cunning of all fiends, the Demon of Theory. This demon is much more subtle and dangerous than those of his brethren who, once upon a time, haggled souls out of unlucky alchemists and architects in exchange for books of spells and plans of cathedrals. He does not frighten you with his horns and fumes

of brimstone, nor make you think twice by exacting signatures with your own blood, and similar alarming legal proceedings. He merely leaves carelessly about the object of your desire, the explanation which will spare you all further fatigue and labour, which will save you from the torment of self-doubt, from the humiliation of self-contradiction as rapidly as will a banker's letter and a cheque book save the penniless wretch from the torment and humiliation of bankruptcy. He himself, I mean this demon, keeps studiously out of the way. You find the unexpected thing which solves all your difficulties, puts an end to all your worries; and in all probability you hasten to pick it up, thanking your good fortune, and wondering at your stupidity in not having noticed before this invaluable piece of property. The demon, who sees all that is going on, laughs in his sleeve. The mouse has walked into the trap. For, strange as it may appear, from

the moment of your pocketing that explanation thus cunningly thrown in your way, you are, to an ever-increasing extent, and for a daily-increasing number of years, the property of that Theory Demon; his serf, whom he can drive to the right or the left, whom he can pinch and prick and pull about to his heart's content; whom he can order either to rob, or murder, or stand indecorously head on the ground, heels in the air; upon whose back he can ride (as other demons ride on witches) to the very Brocken orgy of insanity and falsehood. Mind, I am speaking but too seriously. Let once our vanity or laziness tempt us into neglecting the doubts, the suspicious little facts, which would require a careful and cruel revision of our ideas, which might entail the labour of seeking some new explanation for a thing already explained, the humiliation of an admission that all had been a mistake; let us but give way to this temptation, and we shall

find ourselves, little by little, surrounded by new doubts which must again be quashed; by new facts which must again be set aside; by new injustices which we must commit; by new lies which we must tell, unless we wish the whole edifice of our ideas to crash publicly to the ground; in order to be consistent we shall have become habitual liars; in order not to appear liars, we shall soon appear, what we shall be, fools. Oh, not to slip into the bondage of the Theory Demon, to remain free, and able to be, at least as often as our wits will permit, the scatterer of mere truth, not the kneader up together of a little sense in a great deal of rubbish! The fear of possession by the fiend has always been a disagreeable matter. The poor monks, we know, saw fiends in everything, and scarcely durst blow their nose or wash their hands lest Beelzebub or Mephistopheles might lurk in the handkerchief or in the soap and water. And

similarly with the Demon Theory. If once you have reason to suspect that he is laying traps for you, you are for ever beset by doubts and discouragements. You scarcely venture to handle an idea; you tremble at every liking or disliking, lest it be a prejudice, that demon's invention; and ever and anon you awake with a start of terror, and catching up the explanation of things at which you have been working for months, you rudely pull it to pieces, till no shape is left, and only a heap of disorderly facts remains. Such is your condition if once the suspicion enters your mind that there is danger from the Theory Demon; and such, to some extent, has been my state of mind ever since it occurred to me that the Theory Demon was going to snare me with the subject of association, if, indeed, he had not trapped me already; at which thought my mind shakes and jerks to rid itself of possible meshes.

The matter of Association is simply as follows. I have always felt and expressed that in all our relations with art, association—that is to say, the faculty by which the real presence of one object evokes the imaginary presence of other objects—is a most dangerous and pestilent faculty, leading to insincerity, injustice, and stupid wastefulness, by making us think of things suggested by a work of art instead of attending to the work of art itself. This I have thought and said, and indeed, at the moment of stating my position once more, it seems to me that I was perfectly right. But now comes the mischief. Little by little, watching my own thoughts, my own living, moving, yet unstated thoughts, it appears to me that this very faculty of association is being highly honoured in my mind; that, in a sort of quiet, half-perceptible way, those thoughts of mine are attributing a great deal of good to it; indeed, are making for it

quite a fine position. The question is, Which is the snare laid for me by the Theory Demon—the opinion that association is a pestilent thing, or the opinion that it is excellent, useful, and most honourable? Is the Theory Demon cozening me, or trying to make justice appear to lie in relentless severity towards association, or perhaps more subtly by causing my very fear of injustice to betray me into unwarranted recantation? This is what has been worrying me for a long while, until a circumstance, which has only just taken place, and which brings home to me the wonderful power of this faculty of association (legitimate or illegitimate) in our æsthetic life, has determined me to settle the question by a sort of Oriental or Mediæval proceeding; which is, after having spoken ill of association, and while not really rescinding one word that I said, to write an apology containing all the good things about asso-

ciation of which I can possibly think. In this way, whichever side justice lies, I shall be safe not to miss it.

A week or so ago I was going up the Rhine from Coblentz to Bingen, sitting, not at all enraptured, on the steamboat. I was neither surprised nor vexed at experiencing none of the delight which our fathers and mothers experienced on their first sight of Rhineland; I was not disappointed, because I was perfectly prepared for disappointment. I had clearly realized beforehand how completely the Rhine, with respect to its emotional and imaginative power, is a thing of the past. The imaginative and emotional, the æsthetic habits and wants of people have undergone a great change since the days when the Rhineland was the holy land of romanticism. The mass of mankind scarcely knows what will or what will not give it æsthetic pleasure; it requires specially endowed men, painters and poets, to select and copy bits

of reality; so that having seen and been made to appreciate the picture, it may recognize, appreciate, and, if possible, extend its knowledge of the original. Now the Rhine, harsh as it sounds, is not the sort of thing singled out and copied by the artists of to-day, painters or poets. Our painters do not care for the ostentatious, self-conscious picturesqueness of rocks and river and ruins; they are seeking for the beauty, the wonder of commonplace scenes, they are striving after the tints, the sheen—nay, the very darkness with which nature enrobes most regally the veriest plebeian of a landscape. The poets, on the other hand (or perhaps I should have said the poet Browning, the great showman-in-chief of our imaginative puppet-show), the poets no longer care for ready-made and extremely made-up heroism and romance; for knightly perfection draped in anachronism, and satanic grandeur draped in mystery. What interests them (and I am

speaking not of those who merely paint exquisite unreal decorations of antique or mediæval fashion, but of those who can really react on our lives and tastes) is reality, of past or present; historical knowledge has made them hungry of the realities of former days, of the every-day life of beauty and sordidness, of the rotten heroism and fiendishness and water. In all modern art, the effects which shall move and delight us, the beautiful and the pathetic, are being sought every day more and more by realistic means; and I, for my part, feel that herein our artistic feeling has got on to a far worthier road than in the days of romantic poetry and painting. But, be this as it may, one point is certain, which is that the Rhineland has been gradually pushed out of our own æsthetic and emotional life, and been quietly put by in the lumber-room of superannuated romanticism. These points, explaining why the Rhine should give me but little plea-

sure, I kept revolving in my mind; and, as I sat on the steamer between Coblentz and Bingen, involuntarily conjuring up other scenes, other rocks, rivers, and old towns, comparing, deciding, and seeking to understand my own decisions, the sense became stronger and stronger in my mind, as the water foamed round the paddles and fell in ridges behind the ploughing keel, and the awning flapped in the draught, that for my own part I would willingly give all this romantic Rhineland, rocks, castles, nixes, robber knights, and all, for a reach, pale under the pale blue sky, of poplared and shingled Tuscan river, for a sluggish bend of English stream, flowing you scarce can tell which way, under the willows, beneath the sedge and meadow-sweet, through the low-lying pastures.

But while such were my reasoned ideas, I gradually became aware of the presence within me of something different, diffusing

itself, and permeating my consciousness. Not exactly an idea, nor yet a set of impressions, something impossible to define, because definition is not made for vagueness; first within myself, warming me like a cordial into vague pleasure, then afterwards surrounding me from outside, an all-encompassing medium in which the soul floated with languid enjoyment—pleasurableness slowly produced (as heat is slowly given out by a few embers when we blow upon them) by the sense that this was the Rhineland. The Rhineland, but not the Rhineland as a concrete reality, a sum total of present and actually perceived and analyzed impressions and ideas; not the Rhineland which was now before me, which I was now criticizing, of which at this selfsame moment I was still duly reiterating to myself that it was a thing of former days, no longer in harmony with the imaginative requirements, etc., etc., and the various other subtle remarks which you have read above.

Not this Rhineland; quite another. A Rhineland of the past, but which neither I nor any other mortal had ever seen; one which used only to exist in my childish fancy, and which, wholly different from the reality, was gradually brought back to my memory by names which I had for years forgotten. A Fata Morgana Rhineland, which years and years ago I had constructed —or rather, which had constructed itself for me—from the random allusions, the incoherent descriptions of a servant-maid we had had while living in the neighbourhood of Frankfurt. I must have been a small creature of five or six; she was a buxom thing of eighteen or nineteen, romantic, poetic, and of decayed gentility, as nursemaids in Germany frequently are, or were; a native of the Rhineland, Rheingau as she called it, meaning thereby merely that classic portion between Bingen and Coblentz; all the rest of the river's course, before and after, being apparently non-

existent for her, as it certainly was for me. Of this Rhineland of hers she was perpetually telling, and to me she could never tell enough. She was not from the river bank itself, but from Inland, some small place whose name has completely gone out of my memory; there her father was schoolmaster, her grandfather had been parson; it was the most marvellous region in the whole world; it never appeared to me as having anything in common with the rest of the earth. Everything was wonderful. Fruit trees, the like of which did not exist, covered it with miraculous blossom. Now fruit blossom, the transparent, easily shed pure white of the cherry; the solid creaminess, crowned with tiny pale green leaves, of the pear; the pink-tipped, woolly, unwillingly opening buds of the apple, the various foam-like flowering of all the various kinds of plums, fruit blossom of all kinds always had, I know not whether from the difficulty of obtaining it, its association with sweet taste,

or with the excitement and surprise of spring, or merely from its own peculiar beauty, quite a particular fascination for my childhood. Embosomed in all this were all the other marvels of the girl's birthplace. The father, a schoolmaster such as there never was elsewhere; the parsonage, a parsonage such as there could not be more than one in the world; the parson himself, the grandfather, a grandfather as other folks never possessed one; who had been alive during the French Revolution (the French Revolution had a marvellous power over my imagination), who had seen, spoken to, flouted, repelled (who knows?) Napoleon when he came into Rhineland; an old gentleman whose wonderful wisdom was deeply impressed on my mind, one of his dicta—"The hair of the head, the ornament of mankind, let it hang, let it hang" ("Die Haare des Hauptes, die Zierde der Menschen, lass hängen, lass hängen") remaining in my memory like an oracle.

Moreover, this Rhineland, this particular Rhineland, was full of legends of nixens, castles, treasures, nuns and knights, things which all the world can (in all probability) read in the sixpenny books sold at the stations, but which appeared to me as learned in some occult and direct manner by my nurse, as the emanation of the wonderful country. Of these legends there was, moreover, a mysterious large volume, of which (without ever having set eyes upon it) I can see, brown binding, tapestry work markers and all, at this very moment, so often did I clamour for descriptions of it. It was apparently unique, at least it never seemed to occur to any one that a copy of it might be procured; vague hints were thrown out that some day it should be brought, I should see it and hear the stories read out of it, but it never was brought; having something inscrutable and mirage-like in its nature; and it remained, and still remains, a mysterious object in my imagi-

nation, a wizard book, which, when opened, lets out a cloud of diaphanous figures, knights, water sprites, nuns, enchanted princesses, even as other old books, when clapped open, emit dust from out of their pages. Round this existed the parsonage, moved the father, the grandfather, uncles and cousins, all unique people, in a kind of sea of everlasting fruit blossom. Such was the Rhineland as it existed for me: the land of wonders and joys, too wonderful indeed for approach; the idea never as much as occurring to me to wish, in my wildest wishes, even to penetrate into it. Not a province, not a substantial country, to which you could get by two hours' railway travelling, but a land east of the sun and west of the moon—inexplicable, unapproachable, a thing to sit and wonder on.

All this, long, long, forgotten, gradually returned to my memory with the name (magic names, alas! how long forgotten) of Lorch, Kaub, Rhense, Bacherach, and other

villages by the great stream ; and, while my eyes were staring at the monotonous zigzag of dwarfed vines and stone walls up and down the hillsides, with the battered little castle here and there ; at the white towns with gabled houses and extinguisher steeples spread out primly at the water's edge ; at the little oasis of brilliant green grass, fruit trees, hedges breaking the weariness of the eternal vineyard ; at the solemn grey-green water, on which the huge rafts went in and out like floating spars ; as the logical certainty of the insufficiency of all these sights and associations for us familiar with Italy, admirers of Whistler and readers of " My Last Duchess," came clearer and clearer before what ought to be called, I suppose, the more intelligent portion of my mind ; the rest of my mind, nay, somehow my whole nature, was invaded by the consciousness of that imaginary Rhineland of my childhood. I felt excited, pleased, scarce knowing at what ; and whenever the boats came along-

side the steamer and the cry arose "Boppard," or "Kaub," or "Lorch," the effect was as if I caught distant notes of some once cherished tune, thrilling me faintly, but surely.

Very pleasant, I grant it; but, after all, pleasant things are not necessarily good or proper: to be excessively conceited is pleasant; and pleasant also, doubtless, to have an opium vision of bliss; or to think that a certain number of genuflexions, a certain number of Latin rhymes will gain us admittance to a paradise whose sky is molten gold, and whose every flower is a living jewel; but in all these cases the pleasantness to the individual between whom and the truth such figments interfere, does not diminish by a tittle the moral and intellectual degradation attendant on such hallucinations; and the visions conjured up by our faculty of association are but another form of such hallucinations, and have their attendant degradation. Degradation,

moral and intellectual, you will answer, in moral and intellectual matters; but, after all, what great mischief has arisen if association have its way in artistic matters; if an unreality of the fancy come between us and what are, at best, but the unrealities of art? But I say that degradation it is. The kingdom of beauty is, it is true, only the playground of our lives; but, even as children may soil their frocks, or hurt their playmates, or tread down grass and flowers in the course of their games; so we also may not only trample into unseemliness our æsthetic playground and shatter our æsthetic toys, but also, during our pastimes, become guilty of injury to our neighbours' rights; of destruction of our moral garments; of various things which, when on returning to our serious work and serious lessons, on seeing our playthings in bits, our playmates bruised and battered, our playground devastated, and ourselves tattered and besmirched, may make us feel exceedingly

ashamed. Now, of all tricks which we grown-up folk may play in our æsthetic playground, there are few as mischievous as that trick of association: none certainly affording such opportunities for maltreatment of others, vandalism, and wastefulness. Let us look into the matter. Association means the investing of one object, having characteristics of its own, with the characteristics of some other object: the pushing aside, in short, of reality to make room for the fictions of imagination or memory.

Now, in a work of art, or a thing of nature which can afford artistic pleasure, there is, as in man, woman, beast, plant, or stone, nothing so important as its reality. This reality, this sum total of all its actually existing characteristics, means, in the work of art, all the labour expended upon producing it, all the good luck enjoyed in finding it, all the pleasure that it may give. In practical concerns, this is recognized by every creature: we do our

best to get at the reality of man, woman, beast, or plant, knowing that on that reality depends all it can do for us, or that we must do for it. But in all æsthetical matters the case is different: We do not seek for the reality of the work of art, do not ask ourselves what it is. The reality of a work of art is that by which we recognize and remember, that of which we can make a copy, the identical and individual, which to all men similarly constituted must appear the same: the form, this form, the visible shape of picture or statue, the audible shape of symphony or song; what the artist has conceived, has seen or heard in his mind, which he has perfected in the mere conception, and then laboured to transmit outwardly to us by arranging the paint on the canvas, the bosses in the marble, the relations of the sounds of voice and instruments.

But little knowledge of music is required to realize the work of composing a sym-

phony or a mass: inventing the themes, dovetailing them into each other, distributing them in little bits to the various instruments or voices, and giving to the other instruments and voices something which shall enhance and not impoverish the effect of those main parts. And when the artist has all the science and taste and experience required for all this, when he can drive (without lurching) the frightful twenty-in-hand of counterpoint and orchestration, he yet requires, for his work to be good, a thing considerably rarer than rubies, and, unfortunately, not obtainable for money —the trifle called genius. In the same way, it is good to meditate upon the fact, casually mentioned to me one day by a sculptor friend that a statue intended to be placed, not in a niche, but on a free-standing pedestal, would afford, if every point giving a new relation of points were represented, from twenty to twenty-five possible and different photographs. This simply means

that the sculptor must make a statue which shall present well in twenty or twenty-five ways; after which there remains the perfecting of all this in a minute detail. You may sometimes go to the studio and see the clay model finished, ready for casting; return a week later, and you may, just as soon as not, find the model still there, with perhaps a whole leg and one half of the drapery reduced to an unseemly lump of greenish clay, which the artist is slowly working back into shape, having suddenly grown discontented with such and such a fold of drapery, because, although admirable when looked at in front, it made some trifling lump or point which looked bad at the side. Such is the reality of a good symphony or a good statue; and such is the labour which even genius cannot dispense with in its production. This is the reality, and this is what association immediately proceeds to mar.

The symphony is being performed; and

as, bit by bit, is unfolded that complicated pattern of sounds; as passage follows passage, whose invention may have been a flash of genius, whose arrangement an agony of long unsuccessful effort, you (I mean mankind in general, presumably including myself) who are perhaps the mere unproductive æsthete, sit blandly, a pleasant noise of music soothing or gently stirring your nerves, letting your mind fill (like a leaky boat) with vague thoughts and emotions. The sough of wind among pines, the smell of the forest; the sheen of the sunset on the sea; your dead or distant friends; the soul, its peregrinations through infinity, love, and death (after Burne Jones or Solomon) leading or snaring it, on the way—whither? to the paradise of Fra Angelico, the pink and blue Jerusalem, shimmering among the gilded meadows,— or rather to the whirlpool of atoms, the viewless seas and skies of Nirvâna. Meanwhile things have been going by: happy

movements and combinations; things gone in a second, but, remembering which in moments of disheartenment, the poor composer may have smiled, and the smile may have meant: " There is genius in me after all." These things have gone by: past your mind, your pampered soul, noticed about as much as the long cricket notes through a summer evening's talk; the crackling of the fire during the composition of your last poem—a poem, I would wager, upon the power of music.

Similarly with the statue, one glance, just taking in the general aspect, perhaps another to see how well the stone is cut; and then you contemplate the work with that vague stare which sees nothing; you think of the hero's life, and of his mighty battle-shout, of his tears over his fallen comrade. Of the waves on the Trojan shore, the clear night over the plain dotted with watch-fires; the youth of mankind — Socrates, Sappho, the brutal Roman prætors, and

a whole Panathenaic procession of impertinent associations. Meanwhile the marble stands before you, neither fighting, nor shouting, nor weeping; with no waves or watch-fires near him, and no consciousness of the youth of mankind; a mere comely, naked body, with a wisp of drapery over the arm, and no personality save in the name graven on the pedestal, a name snatched at on its first suggestion by the friend whom the sculptor has asked, " Now, what is this to be called?" Thus poor in sentimental or psychological qualities, but rich with a hundred beauties of line and curve and boss; of light expanded here, and imprisoned and fretted there; of chisel grainings, delicate like sea sand; of bold point-strokes, vigorously marking off bone or sinew; things, all these, which make up the complete reality of the work; things over which the artist may have half broken his heart; and with the vaguest general impression of which you depart, persuaded

that you alone have appreciated the statue, and ready to write (as Winckelmann, who, however, really saw the good points of a statue, used to do) that this masterpiece is altogether moulded out of the most subtle abstract ideas, is, in short, the perfect embodiment of the shapeless.

And this, all this has been the doing of association; a rare and beautiful thing has been within our spiritual reach, and we have not cared to stretch out to grasp it. The genius and patience, the labour of months, nay, rather of years, of all the previous years of the artist and of those from whom he learned, expended to give us an exquisite and exotic pleasure; all this has been wasted, wasted as stupidly and ungratefully as would be wasted the precious fruit brought with infinite care from other climates, of which some captious child might say, after a bite, "Thank you, I prefer the unripe apples I can pick up in the orchard."

What has become of my desire for justice, of my plans of dealing equitably by saying all the good I could think of, while thinking all the ill that could be thought of this abominable faculty of association? I had determined to write an apology, nay, a panegyric, and, instead, I have written a diatribe; the mere name of association has made me acrimonious; acrimonious, but, you cannot deny it, just; because this association really is . . .

Well, yes; that is just the tantalizing thing about association: the more I examine into its workings, the more malignant it appears. And yet, when I am not trying to reason it out, to do justice all round, a great number of things do come into my head illustrative of the beneficial effect; yes, indeed, the beneficial effect, I may even (strange as it may sound) go to the length of saying, the absolutely indispensable character of this faculty of association in our æsthetic perceptions. You

think this an absurdity? You think association can be but detrimental in our relations to art? Well (how idiotic one's own arguments do sound when some one else is using them against one, to be sure!) I am of opinion that without association there would be no relations to art; nay, no art at all. You smile? You say (what I somehow said myself, and now I can't make it square any longer) that as the action of opposition is that of a wave, an allusion of all manner of chaotic thoughts and impressions washing over the definite artistic forms which are settling in our mind; it is evident that the definite artistic forms run the risk of being completely obliterated. That seems to you conclusive: good; that is the very reason why the action of opposition is indispensable to the appreciation, nay, to the creation of artistic form. You have compared the action of association to that of a wave carrying innumerable heterogeneous odds and ends

of thought and impression. As such, in my turn, I claim it as the action which is for ever making the firm soil of our mind; by collecting round the microscopic present all the floatsam of the past, the action which is perpetually preventing the sea of constantly undulating experiences, atoms of sensation and reflection for ever changing place like the drops in the ocean, from reabsorbing everything which might become a permanently existing idea, a definite emotion, a solid form. The floatsam, the bits of triturated imagery and feeling (already soaked and battered into something unlike their original nature) may be brought in too great abundance; and the wave may carry too much of that strange sea froth of sentiment, a thing neither solid nor fluid, and which fast imprisons and dooms to never-ending floating and tossing everything that it once encloses; and thus a something, perhaps rare and precious, may go for ever churned

about among the floatsam and the sea froth, until, rotting, it become mere sea froth itself. The wave of association may deprive us ever and anon of some addition to the little islet of wisdom and beauty of our lives; but had there not been that wave tossing the past to the present, no solid wisdom or beauty, nay, no individuality of ourselves would have existed at all. This is a metaphor; you object, and there is no nonsense so great as not to be made most judicious by metaphorical presentation. Then I will drop the metaphor, and speak the dry language of fact (so often making us lose those sudden revelations of analogy which flash upon us in metaphor). Without association, I say, no art. In the first instance, every modern psychologist who has studied the origin of our æsthetic faculties, will tell you that one half, and that in far more complex, of the instinctive preferences which are the rudiments of all our æsthetic feelings, is referable,

not like the simpler kind of such rudimentary instincts of beauty, to the greater physical comfort which the eye and ear experiences in the perception of certain relations of colour and sound; but to the habit, due to the experience of our remotest half-human progenitors, of associating material pleasure, safety, or usefulness with certain aspects rather than with others. Were we to seek the reasons why a strong and healthy human body of our own race gives us a general sense of beauty which we should not receive from a deformed negro, we should find that the single elements of line, curve, and tint were probably not, in the one case, more agreeable to our nerves of sight than in the other case; we should probably discover that the selfsame lines, curves, and tints were contained in a great number of other objects of which we should call some ugly and others beautiful; and that we must consequently seek the explanation of the

sense of beauty connected with the one figure, and of ugliness connected with the other, in the practical generalization made thousands of years ago, that a body formed in one way was useful and agreeable, and formed in another way useless and cumbersome; in the contempt, moreover, and the suspicious loathing with which savages of a slightly superior race would look upon other savages of a slightly inferior race, their slaves or enemies. The original motive of preference has been obliterated by centuries; just as for years we may forget the original circumstance which directed us to the occupation or friendship which has been the all in all of our lives; but the result of the act of association which took place in ancestors living perhaps before what we call Europe was turned into ice fields; the instinct of preference, the habit of pleasure, have become part and parcel of our nature. Thus, you see, there would never have been any

works of art or any people to appreciate them; nay, there would not have been such faculties as perceive and create the beautiful, had it not been for this same much abused faculty of association. Why did our apelike progenitors enjoy the appearance of a green tree with white blossoms which did not bear eatable fruit, because they remembered the greenness of leaf and whiteness of blossom of a tree which did bear eatable fruit? Why did they not limit their likings to the real, but go loving one thing for the sake of another; the present for the sake of the past? They were sentimental and quite deficient in intellectual discipline. But, alas! had they been less maundering and more logical we should have had no Raphael, no Michael Angelo; we should care to see only the things we can eat. All that, you answer, is perfectly true; but that happened a long time ago; that association was useful in our remotest ancestors

is not a reason that it should be desirable in us. After all, men and women, in early times, lived in caves and on posts in lakes; and had they refused to do so, the human race would have come to an end, and we should not be here to live in houses. But is that a reason why we also should go and live in caves or on posts in a lake? Thus you, chafing my spirit more and more by repeating arguments which are my own, and which I detest proportionately.

I continue.

But as there are cave and lake homes which our ancestors did well to inhabit, and there are also houses which it is fit we should live in, so also are there modes of association which were useful in our ancestors; and different, much more modern modes of association which it would be as fatal for us to regret, as for us to be too grand to live under roofs, and insist upon establishing ourselves on floating cirrus clouds. I have

compared the action of association to that of the wave which brings to the nucleus of solid earth all the floating things which can make soil. Now, do you know what makes our mind, our experience, our genius?

Do you think that we perceive, much less remember, the totally unknown? Not a bit of it; we merely constantly recognize the already familiar; what we catch hold of with our mind is not that which is new, which belongs to to-day; but that which is old, and belongs to yesterday: the different, the new, we take in, tolerate, enjoy, only later. We wander, as it were, through a vast and populous city; those that we notice and speak to are our old acquaintance; but the old acquaintance introduce new ones, whom we admit for their sake. Nay, if we sometimes look twice upon the face of a stranger, if we accost a man of whom we have no knowledge, it is because in the face, the gait, the manner of that

stranger, we have recognized something of the face, the gait, and the manner of some one we have known before; and if, later, we come to love the new friend for qualities in which he differs wholly from the old one, we must not forget that we cared for him at first merely for the things by which he reminded us of that other.

Thus does association gather the past to the present, assimilating for ever new impressions to old ones. Within the mind of all men for whom or through whom the beautiful exists, there has thus come to exist a perpetual coming and going, submerging and rising to the surface of fragments of thought, and feeling, and perception; a chaotic whirl of atoms, of broken-down fragments of works of art, of shreds dyed with some strange sky or wave tint of nature, of mere imperfect silhouettes, and of most heterogeneous dabs of colour; moreover, faces and voices of persons, branches of trees, bars of melody, snatches

of verse, little shreds of mysterious and momentary feelings, of love and hate and hopefulness and sorrow: a perfect witches' caldron full, and seething like a witch broth, each atom seeking the atoms most akin to itself, uniting with them, but usually to be swept back again into the common whirl. Every now and then a curious phenomenon takes place. Whether from the accident of a greater than usual homogeneousness in these seething atoms, or from the accident of some unusually great heat or pressure exercised upon them, or from any other similar cause that you can think of, there arise in this chaos agglomerations which are no longer chaotic; there appear in this constant change things which are stable, mere bubbles at first, but gaining solidity and definiteness every moment; until at length they can actually be removed out of the heterogeneous and never-resting whirl, and be known not merely by him in whose brain they have arisen, but by others also.

And these things, arisen out of the chaos of elements brought together by association, nay, separated from that seething mass, and united with other separating fragments by the power of that very association again, these things are what we call forms: pictures, symphonies, works of art. And there is no stranger thought than that of the great unused, disorderly mass of sights, sounds, feelings, and thoughts, whose existence is proved by the production of certain definite works, and which every artist has carried with him, unused, into his grave. Oh, for a glimpse into that splendid and inestimable chaos out of which have issued the works of Shelley, of Mozart, of Raphael; for a glimpse into the crepuscular places where thronged the dim shapes from among whom Michael Angelo called forth his sullen goddesses and prophets; into the unsubstantial, fluctuating crowd whence Shakespeare evoked Miranda, and Portia, and Romeo, and Lear; or into those untrodden

and intangible woods and dells whence Keats bade Endymion guide his chariot.

Empty and impossible desires; yet not so empty, not so cruelly impossible as the desire, the longing of those in whose mind things of beauty and dignity are for ever turning, are for ever seeming to unite and take shape, merely to fall asunder, and be absorbed once more into chaos.

Thus much for the part played by association in the actual production of beautiful things. Let us see now what is its share in the enjoyment of them. How great this is I realized, perhaps fully, only this summer; realized it not only by a mere filling up of an empty present by a rich past, as in the case of the Rhineland experience which I have told you of; but by suddenly feeling the vivid present accompanied, like some clear melody, by the fainter but fuller harmonies of the past. I had just returned to England, and was walking one morning across one of our south country commons,

all mottled yellowish with tender-sprouting bracken, and rusty, inky green with gorse, and all a-chirrup with young larks. It was of all things the most opposed to the hills, misty grey with olive, the fields all a yellow shimmer of pale green vines and wheat, the diaphanous tints, the sharp but unsubstantial forms of Tuscany, whence I had just come; and it filled me with a sense like that of breathing suddenly a wholly different air, of moving in a different element, as those must feel who rise in a balloon, or dive down deep under water. Folds on folds of green undulation, strips of grass and common enclosed by round trees, and tightened, shrunk by distance, till the horizon is nothing but treetops upon treetops, monotonous in line, for ever the same shape, yet varied, painted by distance into a whole scale of various greens, from the brilliant pure green of the grass under foot, through all manner of yellowish tints and pale brown, of scarce mature or nipped

leaf, to the pure grey, nay, rather blue, of the horizon. There is about that country a great sense of dim and attractive distance, not, as in other places, of beautiful delectable mountains which our fancy vainly seeks to scale, but rather of a possibility, nay, a necessity, of our imagination going on for ever through that easily walked sweetness. Yet, under the grey sky, moister even in its little rifts of blue and its white vapours, moistest, perhaps, in its gleams of sun (which is colour, but not light), which are yellow from the blackness surrounding, this country is not without a certain dreariness and austerity, in the brown and rusty tones of the gorse, of the thinned trees, the blighted hedges, and of the seeded reed clumps; most of all in the damp chilliness of the air and sky. Walking across this common, I was struck by something which reminded me of Brittany, and immediately Brittany came before me —Brittany, with its resemblances and dif-

ferences; with those same folds of bluegreen treed horizon, those same patches of sombre, tarnished rusty gorse. Again, Brittany, with the yellow earth of its lanes, the yellow stubble (the straw being cut at only half length) under the apple trees of its high-lying fields, with the long rows of tall rustling poplars, nested with mistletoe, along the roads, with the beautiful grey featheriness of thatch of its farms and *gentilhommières*. Brittany thus came back, seemed to exist side by side, as a kind of bass to the melody of the really existing present, filling up all gaps, strengthening and softening, making complete the pleasurableness of that English scene. Noticing this, and thinking over it later, it came home to me that in our perceptions of nature and of art there usually exists a kind of phantom of the past, omitting which, we enjoy in a less poignant way (a sort of thrumming accompaniment or set of chords) —the resemblances and diversities between

which and the present occasion a sort of half-unconscious pleasure, nay, the past may exist only in the condition of a harmonic, a sound which we do not disentangle at all in our impressions, but which still forms part of them, marking, by a recognition of some distant and past thing, the qualities of the present. For the present is in itself, however vivid, too transient and thin; like a single bright coat of colour, it requires, in order to remain, a layer or two of the past, unseen, perhaps, but which gives it body, and tone, and stability. Nay, but for this intervention of the past should we perceive the beautiful things of the present, its patterns of lines, and colours, and sounds, in a way more satisfactory than that in which we perceive a single note, or the taste of a fruit, or the warmth of a cloak? There are persons, and many, who, going through a picture gallery which is new to them, or walking through a new country, will frequently complain of a sort of

painful sense that their minds cannot take in new things sufficiently quickly. Now, if you question such people, you will almost invariably find that they have only confused and very general impressions about the galleries and countries which they have previously visited. They compare their brain to a thoroughly soaked sponge, which can absorb no more water. But their simile is false; they suffer not because there is too much past to admit the present, but because they have not enough of that many tinted though faded tapestry of the past, into which to weave, to secure them, the brilliant threads of the present.

These are the benefits which we obtain in our æsthetic life from association; nay, this constant adding of old to new is our æsthetic life itself. Sometimes even one might wish that this life were slower, that impressions were fewer and further between; that one might enjoy to the full the pleasure of going over one's odd impressions, of

noting the ever-changing and fantastic effects of this embroidery of new and old, of the dimmed thread of years and years ago, shot with the vivid purple or scarlet of yesterday. The fact is that our æsthetic life is too crowded or huddled; we have too many arts, too many schools of literature of all times and nations, and we properly enjoy (not even in the present impression, and certainly not in the past) none of them. We are like the inhabitants of certain remote villages in the south of Italy, who, until roads were made in the last century, were unable to export their products and unable also to consume them. We want all our casks and barrels for the new wine, the terrible new wine which seems to be made, not once a year, but once a month, nay, once a week; and we have to empty out into the gutters, like so much stale water, the mellow, the delicate vintage of previous years.

There now—I see you laughing. Laugh-

ing, I suppose, because after having found it so very, very difficult to say one good word for association, I have now made not only an apology, but a panegyric, and that the only drawback I can find is that we cannot so fully enjoy all the benefits of this pestilent faculty. Is that it? Well, I always told you that the very disagreeableness of my position arose from the sense that so much good as well as so much harm could be said of association, and that I wanted to state both. Besides, after all, is it of association itself that I have spoken ill; or is it not rather of the stupid wastefulness of those who indulge in it out of place? Association, I have said, makes art, makes our capacity of enjoying it; nay, makes our minds. Now are we not balking the very end and aim of association when, in order to enjoy its action in ourselves, we neglect its works? Is it not, whenever we let our thoughts wander in the presence of a picture or during the hearing of a symphony, as if

we were to refuse to let a poet read us his verses because we found his conversation so full of poetic charm? Yes, indeed, it is not association which is pestilent; it is our own conceit, our own stupidity, our own want of self-command.

Very self-contradictory. That is your verdict upon me; and it is useless, I suppose, to answer, "Where is the contradiction in saying that fire under some circumstances keeps us alive, and under certain others most effectually puts an end to us?" I have said too much harm to be permitted to say much good; that is always what this just world will not tolerate. Well, then, to be consistent, if possible, at least in the beginning and in the end of my remarks, I will mention a trick sometimes practised by association, and from which you perchance may have suffered, even as did the Emperor Charlemagne, whose melancholy tale is told by Petrarch in his epistles and elsewhere, but best of all by old Burton.

"He foolishly doted," we read in the second volume of the "Anatomy," "upon a woman of mean favour and condition, many years together; wholly delighting in her company, to the great grief and indignation of his friends and followers. When she was dead he did embrace her corpse as Apollo did the bay tree for his Daphne, and caused her coffin (richly embalmed and decked with jewels) to be carried about with him, over which he still lamented. At last a venerable bishop that followed his Court pray'd earnestly to God (commiserating his lord and master's case) to know the true cause of this mad passion, and whence it proceeded; it was revealed to him, in fine, that the cause of the emperor's mad love lay under the dead woman's tongue. The bishop went hastily to the carkas, and took a small ring thence; upon the removal, the emperor abhorred the corpse, and instead of it, fell furiously in love with the bishop; he would not

suffer him to be out of his presence. Which, when the bishop perceived, he flung the ring into the midst of a great lake, where the king then was. From that hour the emperor, neglecting all his other houses, built a fair house in the midst of the marsh, to his infinite expense, and a temple by it where after he was buried, and in which city all his prosperity ever since used to be crowned." Thus the legend of Aix la Chapelle; and to Petrarch, to Burton, to all our wonder-greedy forefathers, the tale seemed marvellous and eery. But, alas! are we not most of us in the same case as Burton's emperor? Have we not, many of us at least, some strange lake, which to others is a mere flat swampy pond, into which the charmed ring of association, taken from off some loved thing, has been, we know not why, cast? Even as the emperor did, so we also sit and stare into the shallow grey waters; and the moving cloud reflections seem to gather

into familiar shapes, and the reeds moaning and creeking as they sway, and the languid, sleepy water lapping dully as it eats into the green, crumbling, spungy ground, have accents which almost bring the tears into our eyes; and we look into the dim water and strain to see the bottom: for in the bottom of our marsh pond, our dreary pool, without trees, or bushy banks or reflected hills, our shallow sheet of water spilt on to the desolate plain, lies the charm, the ring, the potent mysterious something which we shall never see, but always long for. And the fault here belongs to association. But I must end, for I wished to conclude with a word more of the evil of this faculty; and unless I stop at once I may catch myself (but too late) saying that perhaps after all such a Charlemagne's lake may be a blessing.

BOTTICELLI AT THE VILLA LEMMI.

BOTTICELLI AT THE VILLA LEMMI.

A WOODEN frame thick overlaid with paste of sulphur applied to the face of the frescoes; the bricks deftly cut into, sawed, picked away from behind; the sulphur paste frame with adhering painted plaster pulled away from the broken, picked, jagged old wall; a second framework covered with wet gypsum applied to the back of each thin sheet of frescoed plaster; sulphur paste delicately peeled off the painted surface of the plaster, the back of which remains adhering to, encased in, the gypsum; that is the operation. A new back has been substituted for the old

wall; and the frescoes are intact, unspotted, safe, framed, portable, ready for the wooden cases of the packers, the seals of the officials, the van of the railway, the criticism of the experts, the gape of the public. Civilization has driven before it even dead art, even art faded to a ghost; and the pictures which some four hundred years ago Alessandro Botticelli painted in one of the back rooms of the little villa-farm outside Florence, are now upon the wall of the grand staircase of the Louvre.

This is what they have just done, and this is what gives me annoyance. Now, I sincerely think that I am quite without any morbid æsthetic aversion against modern times and modern arrangements: I often feel how much nobler in many ways of generous thought and endeavour, which we sniff at because it has become commonplace, is this prosaic age of ours than many another with which we associate ideas of romance; I sometimes even feel a doubt whether in

several branches of art itself, in its most delicate branch of poetry, these modern times have not given and are not giving work more completely beautiful than the work of times with more pretensions to poetry and picturesqueness. I cannot therefore suspect myself of morbid aversion to modern things and actions. Yet this particular modern action of removing the frescoes from the Villa Lemmi leaves in me a strong, though at first somewhat inarticulate, sense of dissatisfaction. It may be right, this instinctive and vague feeling of displeasure, or it may be wrong, but any way there it is; and my present object is exactly to discover whether this is a selfish and sentimental personal crotchet, or a well-founded and honest conviction. This is what I wish to do; and in order to do it, let me separate from one another the various impressions of the past, the various expectations of the future; let me place in some sort of intelligible order the

fragments of scarce conscious argument, which taken together make up or produce the vaguely painful sense that comes over me every time I remember the removal of those paintings from that place.

The first question which I hit upon in this ransacking of my consciousness, is one in which the explanation of the whole matter may possibly lie. The question is simply whether the removal of those paintings from one locality to another deprives me of a particular kind of pleasure, dependent for me upon the presence of these individual frescoes, in the same manner as the departure of a friend to some other country would deprive me of an analogous kind of pleasure obtainable only from the presence of an individual friend who has gone away. This seems a likely enough explanation, but I do not think it is in any way the true one. There are, indeed, there must be to every one, a certain small number of works of art which

are very much what to each of us is a certain small, very small number of friends; certain books or passages in books, certain pictures or statues, certain pieces of music, never to be able to read which again, to see again or hear once more, would be at the moment of first knowing that these things must be, a sharp pain, and with the passing of time, a sort of vague and dull nostalgia, coming ever and anon in moments of weakness and depression, like the hopeless longing for a face we can see only through a shifting mist of years, for a voice whose tone we can evoke for only one scarcely perceptible instant. Such works of art there must be for all to whom art is anything, although there can be but few from which we can thus be wholly and utterly separated; since a poem, a picture, a piece of music, are things whose identity can be almost indefinitely multiplied, not things, like friends, which live but once and only in one place. But among such things for

me are not those frescoes, nay, not any work of Botticelli. There are personal sympathies in art as in all things, harmonies more or less complete between certain works and certain minds; and Botticelli is to me one of those incompleter harmonies. Not but that I appreciate him: that I could, I think, weigh his merits fairly enough if fairness of judgment were the question, and not personal sympathy. I know him well, familiarly; but he is as one of those persons whom you are for ever meeting without ever especially seeking, familiar from sheer habit, perhaps justly enough appreciated for what they are; one of those people who never give you the satisfaction either of thoroughly liking or thoroughly disliking them, and who at the same time will not permit you to grow indifferent: suddenly charming you, when you are ill-disposed to them, with a look, a turn of the head, an intonation of the voice, and the next time as suddenly leaving you

dissatisfied, rubbing you the wrong way; till the perpetual alternation of liking and not liking, of agreeable surprise and disheartening disappointment grows monotonous, is foreseen; and yet even then the satisfaction of utter indifference is still maliciously withheld, for every now and then there unexpectedly gleams out that look, there vibrates that intonation which charms you, which annoys you, which drags you back again into the routine of surprised pleasure, disappointment, monotony, wearying, and yet too soon interrupted to become indifferent. This is how the matter stands between me and Botticelli; he is more sympathetic and less unsympathetic to me by far than certain of his fellow-workers, but with them I know exactly how much I shall like, how much I shall dislike; and with him, never. No, not even in the same painting. I am made capricious by his capriciousness; I am never in tune, always too high or too low

for him. I always catch myself thinking of this, that, or the other of his works; nay, of the abstract entirety of them all, differently from how I felt when last time I actually was in their presence, from how I shall feel when I actually am in their presence again. Oh the woebegone Madonnas, lanky yet flaccid beneath their bunched-up draperies, all tied in the wrong places, nay, rather strangely ligatured with coloured tapes into strange puffs and strange waists; Madonnas drooping like overblown lilies, yet pinched like frostbitten rosebuds, creatures neither old nor young, with hollow cheeks and baby lips, not consumed by the burning soul within like Perugino's hectic saints, but sallow, languid, life-weary with the fever which haunts the shallow lakes, the pasture-tracts of Southern Tuscany; seated with faces dreary, wistful, peevish, gentle, you know not which, before their bushes of dark-red roses, surrounded by their living hedges of seraph children, with

faces sweet yet cross like their own—faces too large, too small, which?—with massive jaws of obstinacy and vague eyes of dreaminess. Madonnas who half drop their babes in sudden sickening faintness, Christ children too captious and peevish even to cry; poor puzzled, half-pained, half-ravished angels; draperies clinging and flying about in all directions; arms twining, fingers twitching in inextricable knots; world of dissatisfied sentiment, of unpalatable sweetness, of vacant suggestion, of uncomfortable gracefulness, of ill-tempered graciousness, world of aborted beauty and aborted delightfulness, created, with infinite strain and discouragement, by the Florentine silversmith painter, hankering vainly after the perfect elegance and graciousness, the diaphanous sentiment of Umbria, and trying to turn the stiff necks and bend the stolid heads of the strong and ugly models of Filippino, Verrocchio, and Ghirlandajo; to twine and knot the scarves and draperies on their

thick-set bodies, to make solitary and contemplative passion burn in their matter-of-fact and humorous faces, as all such things could be only in the delicate, exquisite, morbid Umbrian boys and women of Perugino. No, this world, thus wearisomely elaborated by Sandro Botticelli, has no attraction for me; it is all bitter, insipid, like certain herbs and the juice pressed out of them; I fail to see the charm, I recognize the repulsion. And yet, even as I write, there crowds into my mind a certain swarm of angels, of eager, earnest, pale young faces, with wavy hair streaked with gold threads, and sweet lips, of which you feel that through them pass clear and fresh choristers' voices, voices which are so vocal, so unlike pipe, or reed, or string, and yet which have in their sweetness a something of the bleating of young sheep, making them but the sweeter; there come before me certain slim, erect, quaint, stag-like figures, all draped in tissues embroidered

with roses, and corn, and gilly-flowers, and others with delicate wreathed tresses drooping on to delicate and infinitely crinkled, half transparent white veils, and certain others yet, with slim and delicate arms, curved-in waists, and slender legs and feet, themselves wreathed, entwined, swaying like some twisted sprays of wind-flowers round some tall and bending wind-shaken reed: with the recollection of them comes a sense of spring, of trees still yellow with first beginnings of leaf, of meadows with the first faint dyes of their later dark-yellow and indigo patternings, of fields green with corn, and grey with still dry branches, of warm sun and cold air, and the sweet unripeness of the early year; and amidst all this, emerging from this vague tangle of impressions, a strange face, an erect long neck, with strange straight joining eyebrows, and thin curled lips, defiant, laughing, fascinating, capricious, capriciousness concentrated, impersonate; the capricious-

ness of the art, of the man, of myself, the capriciousness which will, if I leave these phantoms and go once more to the reality of Botticelli's works, make me meet again only slim and flaccid Madonnas, sickly, puling children, and angels all peevishness and airs and graces.

Such are my individual feelings towards Botticelli's art, and this incompleteness of sympathy between the great Florentine who tried to be an Umbrian and myself—or, if you prefer, my misappreciation of the peculiar exquisiteness and fascination of his work—must make it clear that my sense of dissatisfaction at the removal of his two frescoes from the Villa Lemmi cannot be due to the fact that in losing them I am being deprived of something analogous to the power of seeing and talking with a very dear friend. Moreover, this Florence in which I live is full of Botticelli's works, good and bad; and among those remaining are paintings of his superior to the frescoes

of the Villa Lemmi, and more distinctly attractive to me than they are. So that there can be on my part no sense of deprivation connected with those two particular frescoes. And furthermore, I must make a confession which will help to clear away any erroneous explanations which may still be in the way of the correct one; and that confession is, that less than two months hence I shall be in Paris, in the Louvre, with every opportunity of seeing those two Botticellis again; and that together with the knowledge of this I have the knowledge of the fact that being there, in Paris, in the Louvre, I shall feel no particular craving to look upon those two frescoes once more. Nay, I even foresee a certain avoidance of them; a something more than indifference to their being near at hand, within sight; an almost repugnance to see them in their new place. So that I am obliged to come round again, and seek my explanation elsewhere. Looking again in

my consciousness, the next thing I find is a very strong impression of the time when I saw those frescoes first, of the succeeding visits to them, or rather a vivid group of impressions which used to be connected in my mind with the few words—" the Botticellis at the Villa Lemmi." And as but very few people who lived in Florence or came hither even knew of the existence of these frescoes, discovered not ten years ago, and still unnoticed by the guide-book makers—and you may happen not to be among that small number—and as, moreover, it is now a matter of the past; I think I had better, in order to understand myself and be understood, try and give you an idea of the Villa Lemmi and the going there.

You followed, for some twenty minutes, the road towards Sesto Fiorentino, the castle of Petraia and the other places which lie at the foot of the Monte Morello, whose bleak flanks, shadowing the passing clouds,

are patterned grey on grey, like some huge folds of greyish watered silk; then you turned off by another high road towards the old Medicean villa of Careggi, where Lorenzo died, whose castle-like machicolations and overhanging roof are just visible among the trees, while behind rise the little slopes of the Terzolle valley, grey with olive at the base, dark green and feathery with pine woods at the top, and all dotted with white farms and villas. Thus past one or two villa gates, and then you left the high road suddenly for a little rough short cut, with white walls, rudely patterned and overtopped by the whitish olive branches, on either side; in front rose, against a screen of dark cypress plumes, a little old white house, with heavily grated windows and a belvedere tower, opened out into a delicate pillared loggia, whence the pigeons swooped in flocks into the adjacent fields. That was Villa Lemmi. But you passed the old doorway, surmounted by th

stone escutcheon of Albizi or Tornabuoni, I know not which, and knocked at a wooden door, which being opened, a peasant woman or a little bare-legged brat led you into a kind of farmyard. Past the big mulberry-tree just yellowing into leaf, and the rose and currant bushes; under the stable archway, by the side of the dark cowshed, whence came lowing sounds and scent of hay and dairy; through a yard where the lemon-trees stood in big earthen jars, and the linen hung over the grass on the drying lines; and thence into the cool, dark, cloistered court of the villa—a court whose brick pavement was patterned with yellow and greenish lichen, and in which one's steps sounded drearily; but where the farm maid was drawing water out of the well in the centre, and the farm children were swinging on ropes from the pillars, making the arches resound with laughter and screams. On the first floor a narrow parapeted balcony ran round one side of this

court, and along this you followed the peasant woman clattering in her wooden clogs, with two or three little brown boys and girls, with broad little faces running into a sudden point, and hair cropped or tightly tied in a top-knot, like the children who sing and play, kick their legs and entwine their arms in Luca della Robbia's choir parapet high-reliefs. Then up a sudden step, a narrow door unlocked, and you entered a small, low room, the former scullery of the villa, where, about ten years ago, some kitchen-maid scraping at the wall with her knife laid bare a sudden patch of paint, a shot purple and red bit of drapery, a gold-streaked lock of hair; till, scraping well and ill, they scraped into existence two unguessed frescoes, and out of existence perhaps two for ever lost ones. Of the two frescoes, now in a very different place, the one shows four young women, advancing in hesitating and faltering procession, long, slender, with doubled-girdled, puffing

garments, green and mauve and white; and sweet, soft wistful young heads, vacillating, pouting red lips, and vague, shy grey eyes and loosened light hair, giving I know not what, perhaps some effaced flower, dropping it, with dainty, supple-wristed hands, into a folded cloth held by one dressed in the straight, stiff, foldless russet skirt of a Florentine matron; to the back a half rubbed out portico, a many jetted fountain; and to the side a little curly brown boy with iridescent wings holding an obliterated escutcheon; the whole closed in by a group of pointed pillarets half covered with plaster. The second fresco represents a company of damsels, in richly-hued antique garb, seated in a circle in a laurel grove; their garments once delicately embroidered with threads of gilding. One holds a globe; another, large featured like a statue and of bronzed complexion, rests an architect's square upon her shoulder; below reclines another with a

hand organ and a tambourine; on a raised throne in the middle sits a half-veiled lady holding a bow. Towards her, into this goodly company of sciences and arts, a nymph, a muse, with loosened yellow hair and wistful pointed face, is leading the young Giovanni Pico della Mirandola, stately yet timid; a noble and charming figure in scholar's gown of blue and purple shot silk, his fair long hair combed neatly from under a scarlet cap; a sweet and thoughtful face, thin and pale, with high arched nose and pale eyes, under much-curved, fanciful brows; a something between the scholar, the saint, and the page in his demure boyish elegance; a thing of courts as well as of the study.

These were the frescoes. One looked at them; then, between thus doing, looked also out of the little window, over the shimmering olives, the bright green corn, to where the pines and cypresses of the hillside detached their featheriness against the

sky, and the white houses and tower of Fiesole, and its tiers and tiers of villas, rose high in the distance. And then, when one had given the last glance to the frescoes, and the woman had locked the door behind, one descended into the garden, or farmland; where, against the walls of the old villa, under its bowed-out window gratings, were spaliered any amount of the delicate May roses, of intensest pink, and a scent which made one think of the East, of the rose-gardens of Pæstum, of the paladin Orlando filling his helmet with crushed rose-leaves lest he might hear and be seduced by the song of the birds in the garden of the enchantress Falerina, where the Lamia wound her green coils through the grass, under the orchard trees, and the sirens sat and wove garlands in the clear blue depths of the lake.

Among the confused general impression left by many a visit to the frescoes and the garden, there remains distinct the remem-

brance of one particular late afternoon of spring at the Villa Lemmi. Going away from seeing the frescoes, we stepped on to the rusty old twisted iron balcony, and looked out on to the green country, dripping and misty with the afternoon's rain. A large cherry-tree, its white blossom thinned by budding leaves, was immediately below the balcony; then an expanse of fresh, bright green corn, beaten down by the rain, broken by the pale, scarce budding mulberry-trees, and dotted with farms and villas, undulating away upwards into the olive and cypress covered hills of Careggi; away, paler bluish, greener, and bounded like a lake by the blue slopes of Signa, with here and there a screen of poplars, an isolated black cypress, or a projecting square belfry, the sky and sunset gleaming through its pillars. The sun was setting; emerging, round, immense, rayless, golden, from beneath a bank of vapours, which gradually rolled aside; descending,

yellow among livid cloud and blue cold sky, until it disappeared behind the grey hills simulating a bank of clouds, or the clouds piled up in semblance of a ridge of hills, I know not which, down the Arno; leaving, as soon as it had disappeared, a bright speck, a spark, a glowing ember, on the top of the cloud hill, which grew and sent forth red feathery vapours of flame, turning the light grey cloud which hung above it, clear on the pale blue sky, into the flamelit cloud of smoke hanging over a volcano; filaments of red flame combed like hair at the narrow base, solid masses of turbid smoke-like vapour above. The ember left by the sun glowed redder and redder, sending, slowly and gradually, long yellow rays across the western sky; the glow died gradually away; the white mists wrapped the foot of the Apennine; the volcano red departed slowly from the cloud hills blue and cold; only the lower edge of a grey cloud, wet and distinct above the

high blue sky, still reddened and gilded by the departed blaze. A great greyness and dampness and stillness came over everything at last, till the sky remained white and livid, resting on shoals of heavy vapours. Even thus, four hundred years ago, Botticelli may also have watched the sun set as he left his work in the little quiet farm villa, before hurrying back to the city, or sauntering across the fields to the castellated Careggi yonder, where the Magnificent Lorenzo supped and discussed Plato and improvised verses about falcon hunts, comic paladins, or antique nymphs with Pico and Pulci and Politian.

This sort of impression used to hang to the words, " the Villa Lemmi Botticellis ; " words which have now become meaningless, a mere momentary label, no better than a mere number, for the two frescoes just set up in the Louvre. And it is, I think, this change, this loss, which I vaguely resent every time I think of the removal of the

frescoes. Not merely for myself, since after all I have enjoyed, possessed the past, am by so much richer than my neighbours. Not even merely for those who come too late, to whom the Villa Lemmi will be unknown and the frescoes no better than any other paintings in the huge gallery; since for such persons will still remain other places, if not as perfect as the Villa Lemmi, yet akin to it: convents high among the barren grey hills overlooking the Sienese Maremma, where Signorelli and Sodoma painted while the wind moaned, as it moans now, through the thick cypresses and the pines which fill the ravine below Monte Oliveto; quiet little *scuole* of Venice, where you seek after the long row through the tortuous canals, after the sad green and grey and brown streakings of wall and water, the purple robes and gold-woven linen, the bronzed faces and auburn heads of the altar-pieces of Carpaccio and Bellini; secluded corners of Norman and Breton

towns, where the cathedral stands, with delicate thistles and dog-rose and hawthorn carved in its crumbling grey stone, and plants as delicate as they, stone pinks and long-seeded grasses grow in the crannies of its buttresses and belfry, round which circle the rooks; the cornfields and apple-orchards as near by as the black carved and colonnaded houses of the town: places where art still keeps its old, familiar, original framework of reality, of nature, of human life. The dissatisfaction with which I am filled is the dissatisfaction at no one particular loss, but at a whole tendency whose result is loss, which consists in wantonly ridding ourselves of our most precious artistic possessions; and of which this episode of the removal of the Villa Lemmi frescoes is but one instance among many.

I have said that this modern tendency deprives us of our most valuable artistic possessions; and this will doubtless seem rather an insane speech. For what is the aim of all

modern efforts (however bungling, perhaps, in single instances), if not to save from destruction and to render accessible as great as possible a proportion of the works which former artistic times have bequeathed to us? Towards this purpose every cultured nation spends much of its time and money and brains; galleries are being built on all sides, statues are being dug for wherever any are buried, pictures are being bought up whenever there are any for sale; Vandalism in the shape of defacing restoration or absolute destruction is being watched for and pounced upon in every place where it may be suspected; the whole world is busy in trying to save whatever artistic things have been left us by more productive, but also much more destructive times.

So much for the mere physical, economic, practical side of the matter. But corresponding with it is a quite extraordinary intellectual side: an activity, unknown before our days, in teaching people to

understand the spirit in which all these different works of art have been produced, the historical conditions by which they have been affected, the whole genealogy and rules of precedence of schools and artists: art is not only physically, but intellectually housed, it is as safe from the imbecile misinterpretation of former times as it is from the bullets of former generations of soldiers, the stones of former generations of street-boys, the smoke of long-snuffed-out altar candles. All this is evident, palpable, irrefutable, and all this means that mankind is growing daily more anxious to preserve its artistic properties. Evident, palpable, irrefutable; far be it from me to attempt to disprove it. But there is an artistic possession more valuable than any picture, statue, cathedral, symphony, or poem whatsoever — indeed, the most precious artistic property that we possess. It is the power, the means, the facility, due to the condition both of our minds and of

works of art, of assimilating art into life. Such assimilation means not only the enjoyment at the actual moment of seeing picture or statue, of hearing poem or symphony; but also (what is of more importance) the wealth of garnered-up impression which remains to us when the picture or statue has been long out of sight, the words of the poem have long been forgotten, the chords of the symphony have for years ceased to vibrate. For in the life of each of us there is, or might be, a sort of unseen treasury of beautiful things; we have the power if we choose of carrying with us many a precious immaterial thing, many a tapestry wrought by ourselves out of the threads, imperishably tinted, taken from poem or picture, with which we may deck ourselves when fate leads us into mere whitewashed mental lodgings, or squalid moral gaols; many a beautiful nicknack of thought or feeling, or fragmentary form, which remain to us when we are beggared

of all else; and again, many a thing which will enhance the already excellent things, which will be as unseen lutes or viols with which to make music through the silent spring evening meadows, the silent autumn woods. A great stock of wealth, all contained in a tiny, nay, invisible thing, much more valuable than any purse of old Fortunatus: a stock also, and mind this, of real wealth, not of the mere delusions with which in our weakness we try sometimes to sweeten our life, the dreams of passion and worship, to enjoy which we must waste our precious time in sleep, merely to wake up poorer and sadder than before. This we have, or might have; and to obtain it we require not merely to enjoy art superficially, momentarily, but to assimilate it into our nature, to make its impressions our own. But this possibility of assimilation of art into life cannot be obtained by the mere wishing; it depends upon conditions which we can produce, and

which we can also, and frequently do, prevent. As recognition means previous knowledge, so does assimilation mean a certain homogeneousness between that which absorbs and that which is absorbed; and this seems to be the case far more in intellectual and moral matters than in mere physical ones. Completely new impressions are not perceived, since the very organs of perception are formed by the repetition of a but slightly varying act of perceiving; the harmonic combinations which seem most obvious to our ears would probably have left but a completely muddled impression on even the most musical of the men of antiquity. Hence it is that if artistic impressions are to be assimilated into our life, there must already exist in our life a habit of impression akin to those given wholesale by art; and also that there must be in the manner in which artistic impressions are presented to us something familiar, something analogous to the manner in

which we obtain the ordinary inartistic impressions of life. There must, for such assimilations of art into life, be a rudiment of art already in life, and a habit of life still clinging to art.

The rudiment of art exists in our life from the very nature and origin of art; since those instincts which make us appreciate the complex things of art have originated and developed during our contact with the things of reality; we love, in nature, those lines, colours, shapes, and so forth, which art later combines for us on a larger scale; we love the elements of the work before the work itself is dreamed of. Thus the first condition for real artistic assimilation is already partly fulfilled from the very origin and history of our artistic perceptions. And quite of late, in our own country particularly, there has been a half-instinctive, half-deliberate attempt at supplying that much of the necessary familiarity with beautiful form and colour

which is not provided by the hills and clouds and trees all about us. For, as during the best period of Antiquity and the Middle Ages, with that flower of theirs which we call the Renaissance, the extraordinary activity of perception of form and colour produced not merely the imperishable works of independent and useless art, but also a great amount of beauty in all manner of humble, useful things; so, by a sort of reversing of phenomena, the laboriously acquired appreciation of the qualities of great works of art has in our time produced among a minority a greater irritability of artistic perception, a dissatisfaction with ugliness in common household properties, which has made people seek to surround themselves no longer with the hideous furniture, hangings, and utensils of twenty years ago, but with copies of those of the days when the sense of beauty which built cathedrals and painted Sixtine frescoes had its way

also with the meanest chairs and tables and pots and pans. There are, indeed, some persons whom a smattering of modern ideas concerning the spontaneity of all things has made suspicious and contemptuous of this sudden preoccupation about the shapes of chairs and tables, and the colours of carpets and chintzes; and who, because this movement is the result of deliberate study, and therefore artificial, predict that it must for this reason be sterile. But the processes to which we owe so many now apparently spontaneous things, transplantation, irrigation, cropping, grafting, are all of them perfectly deliberate and artificial acts; and as in point of fact all progress has originated in a minority, and the sole condition of its success is that the majority should be prepared to accept it, I think that this modern attempt at æsthetic improvement will certainly result, if not in improving our own art, at least in making us far

more appreciative of the art of other times. For just as it seems doubtful whether a person who has always contemplated with perfect satisfied familiarity a sofa or wall-paper of hideous design and abominable colour, will really enjoy in a statue by Praxiteles or a picture by Titian design or colour which is beautiful; so also is it probable that a person accustomed from childhood to beautiful tones and colour in the carpet and walls of his room, will be far more likely to seek in statue or picture not psychological problems, historic evidence, or romantic (and usually utterly gratuitous) suggestion, but the kind of beauty with which he is familiar in homely things, and of which these great works are merely the most splendid development. With this desire to introduce beauty into ordinary things is intimately connected another tendency of our day, but which has a moral as well as an artistic bearing —the noble tendency to make beauty acces-

sible and familiar to every educated person. Art, when limited to such works as can be bought only by the very rich, becomes little better than the concomitant of French cookery, dresses from Worth, and hideously set diamonds: an object of ostentatious luxury; whereas if only a little of the artistic power concentrated in such work could be bestowed upon things of easy multiplication, small price, and ordinary use, it would not only bring pleasure into many lives in which pleasure is as scarce as flowers in a close, smoky town, but also train innumerable men and women into an habitual perception of beauty, without which they must wander through all the galleries provided for them by the nation with mere vacant, unfamiliar wonder, and leave them as poor of durable artistic impressions as they entered them. There are, doubtless, many things for which the writer must always envy the artist, greater freedom and charm of impression, and

the ineffably delightful sense that he is reproducing and not merely reminding, showing and not merely suggesting; yet the writer has a more than compensating satisfaction in the thought that if pleasure he can give at all, he will give it to thousands of distant, unknown, pleasure-poor people; and this sort of feeling can nowadays, when little is to be done in the way of public monuments, be got by the artist only by condescending or in reality rising to the level of such designing as can either be largely diffused for household properties or as can be indefinitely multiplied and put within reach of all, as in illustrations, Christmas cards, toy-books, and similar humble things. But of this, and of the far more honourable position occupied by men like Mr. Randolph Caldecott or Mr. Walter Crane than by many a fastidious genius who produces works worthy of Giorgione or of Velasquez, in order that they may grace the smoking-room of an " h "-less

cotton-spinner, or the staircase of a Jewish broker, much more should be said than I can say in this place.

I let myself be tempted into digression upon a subject in which the moral dignity of art, or rather of artists, seems to me greatly concerned, just at the moment when I had pointed out that of the two conditions necessary for the assimilation of artistic impressions into life, the one, namely, that the rudimentary perceptions of form and colour beauty should already be familiar to us before we go to great art, was not only partially provided by our natural surroundings, but further and most importantly facilitated by the recent movement in favour of giving beauty of form and colour to the necessaries which surround our daily home life. But there remains the other condition, whose fulfilment seems to me almost as necessary for the real absorption of art into life—the condition that there should be in our

manner of receiving artistic impressions something analogous to that absence of strain, that familiarity with which we unconsciously assimilate the other impressions of our lives. Now, it so happens that the tendency of our time is towards rendering more and more difficult the fulfilment of this second condition, and that this is due to that self-same interest in art which has been so beneficial in beautifying common things; by the same droll, but quite accountable, self-contradiction which makes enthusiasts for old architecture combine to protect the horrid disfigurement of historic buildings by the architects of the seventeenth and eighteenth century because they are in terror of the possible disfigurement thereof by the architects of our own day; the protection against modern Vandalism being freely extended to the Vandal work of the past. For this comparatively recent preoccupation about art has, while tending to surround ordinary men and women with

beautiful furniture and accessories, at the same time induced a perfect habit of removing works of art from their natural and often beautiful surroundings in order to place them in a kind of artificial stony Arabia of vacuity and ugliness. I should call this the modern gallery-and-concert tendency. We are so horribly afraid that a picture should get damaged by the smoke of the candles on the altar whence its Madonna, seated on her carpeted throne before the lemon spaliers, and its viol-and-lute-playing angels rise almost fairy-like from among the freshly-cut sweet peas and roses, the scarlet pomegranate, and bright pink oleander blossoms in the coarse jars before it; we are so horribly afraid that smoke or sacristan (both freely taken into account by the painter) should possibly injure this picture, that we hasten to buy it, new frame it, stick it up under the glaring light of a gallery, among six dozen other pictures which either kill or are

killed by it, with perhaps the additional charm of a plate glass, which reflects the outlines of the benches and chairs and the beautiful faces of the gaping or loafing visitors. And in our fervent appreciation we thus make it infinitely more difficult for the work of art to be appreciated. No, not appreciated; I have used the wrong word. We *do* appreciate our works of art; we know all about the filiation of the schools and the characteristics of the epoch; we know, every ignoramus of us, that, after all, there are only three or four Leonardos and two Giorgiones in the wide world, that all the other exquisite things are " mere school-work, or by some imitator of the seventeenth century." We know that we must not let our feelings cozen us with respect to antiques; that, after all, we have only five or six utterly battered pieces of stone which can be unhesitatingly proved to be the statues mentioned by Pausanias, all the rest being the

less talked of the better. All this we know, and the going to a gallery becomes daily more like a solemn sitting in judgment or listening to evidence; we grow every day more and more appreciative.

But do we enjoy more and more, or less and less? Enjoy freely and simply; let the impressions sink deliciously into us; keep them clinging to us as the unfading perfume of certain Eastern essences? I think, if we ask ourselves honestly, we shall find that we do so daily less and less. We shall find that even as some of our moments of keenest musical pleasure have been during the casual hearing, in a church into which we have strayed, from a window as we passed along the street, some familiar melody sung certainly not by Madame Patti, played certainly not by Joachim or Rubinstein; so also the impressions of full artistic enjoyment are strongest, not from mornings in the Elgin Room or the Louvre, but from an hour or so of ram-

bling through some old town like Verona, or Padua, or Siena, where we have found some picture by Girolamo dai Libri, or Moroni, or Sodoma isolated over an altar, in the place, among the cheap finery, the tarnished finery, in the solitude and silence for which it was painted by its artist.

But we are too persuaded of the awful value of art to leave it where it can be quietly enjoyed; instead of letting it crumble into vague impressions which are the rich and fruitful soil of our mind, we like to embalm art, to mummify it splendidly, to let it grow into a useless, utterly inorganic, unassimilated piece of grandeur. The fact is that instead of considering a fine statue or picture or piece of music as something very akin, in mode of impressing us and value, to a fine group of trees, or a fine sheet of water, or a fine cluster of clouds, we have contracted an almost unconscious but intensely strong habit of considering such

things from an historical, scientific, state-record point of view: as a papyrus of Pharaoh or a prepared cobra in a glass jar. Hence we have for our artistic heirlooms scruples exactly like those we should have about such scientific grimcracks. If a papyrus is incomplete, we do not set our learned men to patching it; and if a statue is hideously mutilated, we do not let our artists restore it; entirely overlooking the fact that the only value of the papyrus is in the authenticated facts it hands down from antiquity, whereas the only value of the statue is the beauty which that unrepaired mutilation may easily have marred. I am far from thinking that the Renaissance was right in having modern arms given to figures which had quite balance and completeness enough without such restorations; I am thinking at present of the question of noses and their absence; and I am well aware that I shall be set down as an utter Vandal

for suggesting the mere question whether the worst restoration is not a less barbarity for us to inflict than the deliberate condemnation of some noble antique head to continue for ever a partial eyesore? Yet, feeling myself already a Vandal, I am hardened to the accusation, and I put forward my suggestion, which is as follows: No modern nose could disfigure or alter an antique head one-millionth part as much as that hideous wound (as in our lovely Demeter of the British Museum) which not only alters the whole relations of the features and distorts the most beautiful face by its unseemly rough flatness and its stump between eyes and mouth, but gives a loathsome sense of disease as completely distorting of the intellectual aspect of an antique as the physical mutilation is of its visual beauty. Nor do I know whether a collection of Phidian and Praxitelian gods and goddesses, looking like so many maimed and

scrofulous creatures out of Orcagna's Triumph of Death, would have pleased a Greek; nor whether in our prudery about restoration we are not in reality respecting less the genius of the great masters who planned whole, entire, healthy figures, than a ragamuffin's hand which defaced their work. Be this as it may, our modern fear of restoration greatly increases, instead of diminishing, the natural difficulty of assimilating impressions of beauty. It is left to our minds to reconstruct the mutilated statues; and after the greatest strain in this direction, we go away with the impression not so much of sane, living beauty, as of depressing, puzzling, and often actually revolting imperfection.

Another form of this modern appreciation of art, which makes art more and more difficult to assimilate into life, is the indignation of many people at such hotchpotch things as operas; because in every opera there is so much that is wholly

unmusical, or of small musical value; because an opera is not the same serious concern as an oratorio or a concert. It is perfectly true, as for instance Mr. Edmund Gurney has pointed out, that there is no possibility of making an opera into a well-blended mixture of several arts. But just for that reason there is in this incongruous hotch-potch a power of bringing art into life much greater than there is in oratorio or concert. The strain of a concert, of the mere attention of the ear for two hours, while the mind and eye remain idle, is æsthetically wrong: it taxes instead of refreshing the musical sense; it is good for people who want to know what certain music is like, not for people who want to enjoy it. In the opera, on the contrary, the musical impressions are separated into groups by other æsthetical impressions or by impressions of real life: the melodies may be taken or left at will, a *sine quâ non*

this of all æsthetical enjoyment; they are not forced upon us whether we be fit to enjoy them or not. An opera is a sort of little epitome of life: you move, look about, follow an action with eyes and mind, look at faces, dresses, and movements, take in words and sights; see and chat with your friends; and if, with all this, you listen to the music, it is freely, as you would listen to the sound of birds among the numerous impressions of a walk in the country. It is quite wonderful how a little cheap plot, a little cheap scenery, dress and gesticulation, a little cheap words, a little talk with a neighbour or watching of unknown faces, how all this trumpery refreshes, enables one really to assimilate music. The explanation is that in this case our life, into which the music (if it is to be of any use) is to be absorbed, is going on, has all its powers of assimilation due to easy and general excitement. In the case

of a concert our minds are tied as with a ligature: we may plunge our soul in music, but our spiritual life-blood is stagnant, and we are neither warmed nor refreshed. The difference between an opera and a concert is that between a town, with all its trivial details and its statues and pictures here and there, and an awful expanse of gallery.

Hence I have called this modern tendency towards isolating art of life, the gallery-and-concert tendency; and it is very principally as a signal example of this gallery-and-concert tendency that I resent the removal of the Botticellis from the Villa Lemmi. The villa with its frescoes was like some quiet evening with open windows, when the music is interrupted by conversation; and when the sough of the trees and the chirping of the crickets outside, the noise of the children on the stairs within, keeps up a sense that besides art nature exists and life goes on. Of course such matters are

often purely economical: a man cannot be expected to forego many thousands of francs for the sake of the superior artistic pleasure of a very few strangers, nor can a nation be expected to be so civilized as to prefer possessing frescoes among exquisite surroundings hundreds of miles off, to possessing those same frescoes among arid surroundings within a few yards. No one can blame the owner of Villa Lemmi for selling his frescoes, nor the French Government for buying them. But those should be blamed to whom the kind of action typified by this Villa Lemmi business is a matter of great pride and self-congratulation, a sort of triumph of civilization: the daily increasing class of people who care for art, but who see nevertheless in any statue or picture still unmolested in its original church villa, merely a sort of huge æsthetic specimen, which must be immediately uprooted or run through with a pin, that it may as soon

as possible enrich some artistic herbarium, or collection of dead butterflies.

Meanwhile the little villa near Careggi looks as if nothing more wonderful or important than the reaping of the corn, the bleaching of the wheat, the birth of an additional calf or farmer's brat, had taken place since this time last year. The red cart is drawn up outside the old gate with its stone escutcheon, while the vegetables from the garden or the barrels from the vineyard on the hillside are being piled into it; and the row of bells on the horse's brass-studded harness jingle as he shakes his fly-worried head; the cows are still being milked in the dark stable by the pale-green mulberry-tree; the vines still pruned on the spalier along the blackened wall; the roses still blow, and shed their pink petals on the strawberry beds all round the house; the brass pitcher still goes up and down on its wire through the lichen-stained, cloistered court; the

peasant children still swing between the columns; the old villa, with its square tower opened into a pillared loggia, looks just the same among the green cornfields and dark cypresses, against its background of olive-grey hills. The same as it did last year; the same, most likely, as it did four hundred years ago. It has lost its frescoes; but, for all the greatness of Botticelli, it has lost less than have lost those poor, hustled, jostled paintings, expatriated, exiled on to that Louvre staircase. And, though it be quite forgotten and neglected henceforward, the Villa Lemmi has lost less than have we, good, self-satisfied people, in losing the sense that a painting is better in a farmhouse where it can be enjoyed, than in the most superb gallery where it will be overlooked.

ROCOCO.

ROCOCO.

A POLITE editor has recently sent me, in recognition of certain studies I once made of Italian eighteenth-century things, a copy of a fine new edition of the complete fairy plays of Carlo Gozzi. I feel flattered, and greatly obliged. But I feel also within myself an odd, mixed feeling, half pleasurable, half sad, as if an old playfellow had suddenly thought of presenting me with some particular sweet or some particular toy for which I may have had a passion — now long forgotten — in my childhood. Most children—at least, I wish to believe it — are consumed by violent passions less material than those which are satisfied at the pastrycook's or the fruit-stall.

Passions, strong, ideal, all-absorbing, such as can exist, perhaps, only when our fancy has not yet been messed and muddled away over realities; and is able to spread its wings freely, unconscious of the frontier of the possible and the impossible. At that time of life we are probably already in possession of whatever reasoning power and passion we may ever possess; what is missing is merely experience. We are like people born blind, and whom an operation has suddenly given—I cannot say restored to—sight: we see things and their qualities, colours and shapes; but we do not perceive, we do not yet feel, the proportions and the distances that exist between them. The moon is up there in the heavens: big, round, white, bright; and we put out our hand to snatch it. We see things without the intellectual connection furnished by experience; but as we are fully possessed of logic and imagination, we weave round everything a mystic net-

work of unreal relations—half understood, mysterious, which has the strange sparkle of those thinnest of all cobwebs, called, in France, threads of the Virgin, that are stretched, intangible, white, flaming with dew diamonds, on every hedge in early autumn. It is at this moment of our life that we experience those imaginative passions, inexplicable, dumb, almost tragically serious, for some historic personage, at whose very name we redden or shed tears; for the people of the Middle Ages, as they exist in the novels of Scott, of Ainsworth, and G. P. R. James; for the Indians of Chateaubriand, of Fenimore Cooper, and Aymard. Passions, all these, which we conceal from all grown-up folk, because we know they would make fun of them; and we feel that, in this case, making fun would be something like sacrilege.

To me, who had remained, like the Prince Parzival of Wolfram and of Wag-

ner, a child and an idiot long after the legitimate period, there came, after the usual passions for Joan of Arc and Marie Antoinette, after the more fervid passion for the Natchez, the Sioux, and especially the inconvenient and entrancing Mohicans —a passion, be it said, which made me walk along the beach looking pathetically in the direction where America probably lies or swims—after all these childish passions, there came then to me an unaccountable passion for the people and things of the eighteenth century, and more particularly of the eighteenth century in Italy. How it arose would be difficult to explain; perhaps mainly from the delight which I received from the melodies of Mozart and Gluck, picked out with three fingers on the piano. I followed those sounds; I pursued them, and I found myself in the midst of the Italian eighteenth century.

I found myself in the midst of the Italian

eighteenth century. I have selected that form of words with the intention of your taking it literally. I really did find my way into that period, and really did live in it; for I began to see only the things belonging thereunto; and I had little or no connection with anything else. The eighteenth century existed for me as a reality, surrounded by faint and fluctuating shadows, which shadows were simply the present. Things presented themselves to me only from their eighteenth-century side, real or—very often—imaginary. I meditated over such houses as had probably been built in the last century; or, if they were visibly older, I directed my attention upon such portions of their existence as lay in that time; I didn't care a pin about the Renaissance, or Antiquity, or the Middle Ages. In Rome—the scene of all this—my particular predilection was the little shell-shaped square of Sant' Ignazio, where the semi-

circle of houses, each with its plaster laurel-branch and shell, its little balconies of twisted iron, seems arranged as a background for a comedy by Goldoni.

Behind our house, under the wall of the Pincian, there were still the ruins of the old Aliberti Theatre; and many are the half-hours I spent leaning on the kitchen balcony and dreaming of the songs of Pergolisi and Paisiello which had once sounded among the broken and burnt-out walls of that famous theatre; songs which I nearly succeeded in hearing, accompanied by the creaking of the bucket journeying along its iron wire, the final plop when it dived into the well, the screams of the children playing in the garden, and the snatches of song of the maids washing up the dishes.

And then in spring, wandering under the huge ilexes, or on the anemone-starred grass of the majestic Roman villas, I would think of the rows of gilded coaches that used to draw up before the little palace, of the

companies of ladies and cavaliers, in powder and patches, who had once formed bright spots of colour on the blackness of the avenues. Or, if the something so supremely spring-like, the something in those flowering pastures beneath the pines and the bay-trees that inevitably suggests Proserpine and the valley of Enna, brought up to my mind more pastoral images, the shepherds and shepherdesses were always little figures of Dresden china with embroidered waistcoat and *andrienne.*

I began to study that period—to read the books, even the newspapers, of the last century, which seemed to me full of actuality. The dingy bookstalls, the rows of useless and dirty old books exhibited for sale along the walls of palaces and churches, had for me a magical attraction. I became, I may boast, a remarkably well-educated young person of the end of the eighteenth century, perfectly up to all the last new

things of that time, and able to cut a very pretty figure, discussing encyclopedism, rival composers and singers, nay, even personal tittle-tattle, in the *salon* of some Arcadian muse.

But I was not satisfied with reading. I should have liked to see, to hear; if not directly, at least through the mediumship of some one who had seen and heard the things of those days. There was in me a vague hope of being able to come nearer to that century, of finding, in some mystic way and mystic place, a hidden corner thereof. I was tremendously interested in very old people, hoping that they might bring me into contact with the days of their childhood; for I forgot all that immense sea of nineteenth century in which their few impressions of earlier times must have got drowned, or at least discoloured; and many disappointments did not quell my ardour in seeking out these precious half-living relics of my beloved period. The

disappointments were numerous. But, on the other hand, how delightful when this or that old creature said, "When I was a child they used still to act Metastasio's plays;" or, "My father used to talk of the way Pacchierotti sang at Lucca in 1780"! What a moment that was when my dear old singing master suddenly remembered that he had heard Cimarosa sing some of his own comic songs!

My dreams of a sort of St. Brandan's Isle, containing somewhat of the life of my dear eighteenth century, were, I need scarcely say, never realized. But every now and then I came upon some little corner whence that century seemed to have only just departed, leaving in the atmosphere a faint smell of musk and hair-powder.

Such a place was the little villa (I fancy now turned into a *café concert !*), surrounded by a pretty bit of garden which had once been the *Parrhasian Grove* of the Roman

Academy of Arcadian Shepherds. The house was full of old portraits; the neglected garden was bright in May and June with flowers sprung, so to speak, from the bulbs and slips planted in former days—an elegy which you touched with your hand and trod under foot.

Another such place was the former convent of San Giacomo Maggiore at Bologna, converted into a music school by the prefects of Napoleon. How many happy hours have I not spent in those halls, in those refectories and cells, from whose walls looked down a crowd of composers and singers and noble amateurs in bobwigs or pigtails, doing the dignified or the graceful, leaning on their harpsichords, a music-roll in their hands, smirking fatuously at the forgetful world! For me a visit to that place was a visit of ceremony; I invariably took a fresh pair of gloves. You could not present yourself badly got up before all those distinguished and delicately dressed people.

And, of course, in that crowd of poets and composers, and singers and fine ladies, there was always one particular person whom I worshipped, growing perfectly crimson with rage every time that he or she was lightly spoken of in some old memoir or letter. I knew them very well, these delightful objects of my adoration, but only from a distance, on account of the excessive respect and admiration, which made me as timid as a half-fledged boy coming for the first time into a drawing-room full of ladies.

The result of all this fantasticating, of this unconsciously acted romance, was naturally enough a real and genuine romance, I mean a romance on paper. I conceived a grand historico-musical novel, on the model of *Consuelo*, but only far, far more beautiful and interesting. There was to be a little German Court of the early

eighteenth century, a crazy Elector, a philanthropic and despotic minister, a perfidious favourite dwarf, some delightful ladies, and an Italian singer, the hero and *Deus ex machinâ* of the whole: a perfect eighteenth-century ideal of the Télémaque, Sir Charles Grandison, and Re Pastore sort. Round these persons moved a crowd of politicians, of philosophers, of poets, and of villains, all of whom discussed during chapters and chapters the "Theory of Sensations" of Locke and Helvétius, the musical reforms of Gluck, the "Contrat Social" of Rousseau; subjects that in my eyes were palpitating with activity. This novel was my companion during several years—my companion, be it understood, only in my own head. I wrote little of it, and with extreme slowness, perpetually adding and altering. There was no hurry. All my life was before me wherein to write this masterpiece; and it would be a well-employed life. Why

begin at once? Was there not plenty of time?

Thus I argued. But there was a possibility which had not entered into my calculations. A horrible possibility! to which I can barely bring myself to allude; a possibility the thought of which would have been a profanation. The possibility that, as time went by, I might . . . No. The thought never dawned in my mind. I remained perfectly loyal. I continued to believe most sincerely in my eighteenth-century novel, and my duty of writing it. But somehow, I cannot tell how, it so happened that I began little by little to take an interest also in things which had no connection with the eighteenth century. I persevered in my *rococo* studies, but to them I gradually added others, studies, for instance, of the art of Antiquity and the Renaissance.

And gradually, insidiously, I became

absorbed in them. I went on thinking about the eighteenth century, but no longer in the same way. I determined to write a book about it, but the book was no longer that famous novel. It became necessary to explain to the world that this despised eighteenth century was most important in the history of art; that, in the domain of music and the drama, it takes rank among the great artistic periods of the world's history, along with the times of Pericles and of Leo X.

Pericles; Leo X.; history of art; artistic periods! how little did I understand at that moment the meaning of all this sudden eruption of philosophical and historical Hegelian verbiage! I really imagined that I loved the eighteenth century as much as ever. Alas, all this phraseology of modern criticism signified that my much-loved century had ceased to be alive, that it had become, in my eyes, a mere corpse, and that I was preparing to dissect it! It sig-

nified that I looked at it no longer from within, but from without; that in issuing from the eighteenth century, I had emerged also out of childhood; that the days of great imaginative passions, of Joan of Arc and Marie Antoinette, of Sioux and Mohicans, were gone by for ever.

PROSAIC MUSIC AND POETIC MUSIC.

PROSAIC MUSIC AND POETIC MUSIC.

THE blaring trumpets of the Prologue in Heaven, the thundering hymns of the Epilogue, were still shrilling and rumbling in my ears, like the echoes of a distant storm; my fancy was crowded with all that phantasmagoric jumble and jostle of mediæval and antique things, Faustus, Helen, the devil, the witches, the sirens and oreads, of Boito's *Mefistofele*; when I went to hear for the second time an opera I am very fond of, the *Matrimonio Segreto*. To hear within forty-eight hours an opera by Boito and an opera of Cimarosa's, is an æsthetic experience such as presents itself

rarely. It means a meeting of incongruous and hostile things, rather like that very adventure of Dr. Faustus and Helen of Troy, of whom we have been speaking.

'Tis a fantastic experience, this meeting of the arch-modern with the old-fashioned, of an art literally of the future, seeking for new horizons and countries unexplored, and an art which might be called of the more than past—fitting into some verbal conjugation which means " a thing that has been and never will be again," unknown to our miserable grammars. A fantastic experience in itself, and one which results rather in disconnected bizarre impressions, than in such critical theories as are manufactured with ruler and compasses. You are therefore requested to expect in the following remarks neither logical sequence nor æsthetic principles. Should you persist in so doing, you would be disappointed, like those friends of Hoffman's crazy Kapellmeister Kreisler, who, having dropped the

snuffers into his piano and broken the principal strings, had the happy thought of describing in words the things he had intended to suggest with his notes.

* * * * *

That blast of the seven trumpets, those strange shivered chords, the earthquake rumble of all that orchestra, and the anthem which issues out of it all, strong and placid like a rift of blue sky when the clouds have been torn asunder after the blackness of the storm; this cosmic or seraphic drama, fitter for Dante than for Goethe, goes to my brain as goes only one other thing—a fragment of a psalm by Benedetto Marcello, poet and composer, imaginative and aristocratically eclectic artist, artistic ancestor of Arrigo Boito.

Then there is that serenade, that invocation of the siren, which we must imagine those two demi-goddesses singing, not as on the stage (for the stage is the death of

all poetic conceptions), stupidly standing before the footlights, but wandering with interlaced hands through some island garden, some orchard inundated by the moon, and surrounded by the misty moonlit sea; the tremulousness of the moonlight, the throb of the sea, the thrill of the hidden insects, the alternate slumbering and awakening of the wanderer's fancy, all contained in that duet. But there is something more beautiful still and more fascinating. I mean that duet in the prison between Faust and the poor crazy Margaret, that tranquil wavelike swaying upon those two or three notes, which widens like the circles in the water, from one modulation gently to the other, while the words describe, what the music seems to give, the lapping of the tide on that shore untrodden by all earthly cares.

Poetic music this, suggestive; and which, besides its own beauty, seems to give us something more, and more exquisite than

itself. No; not more exquisite, but more subtle and elusory.

* * * * *

The long and the short of the matter, in all that confusion of the *Matrimonio Segreto*, is simply this, that an old noodle, who is also as deaf as a post, wants to marry his daughter, already secretly married to the shop-boy, to an English nobleman called Milordo Robinson, an extraordinary grasshopper being with green coat-tails down to his heels, and a starched necktie up to his eyes; while, on the other hand, the same counter-jumping young hero is being made red-hot love to by the sister of his employer, a toothless and sentimental Tabitha. Hence endless mistakes and misunderstandings, with consequent tremendous bickerings, rages, blows, laughter, feminine shrillnesses and masculine bellowings. As to the poetic element, it enters into the business to much the same extent as it would in reality—that is to say, not at all. And here I may

parenthetically remark, that in the way of *poetic suggestiveness*, except in so far as it is distilled by our modern brains on contact with the past, there is not much to be squeezed out of the good folk of the eighteenth century.

And yet . . . while I watch these domestic battles of a respectable shopkeeper's household of the year 1792: this love-making of what looks like an abigail in striped skirt and coloured apron, and a footman in topboots and a pigtail; all this while I feel something moving about in my fancy, which something or other is not prose, is not caricature; nay, which is, putting it quite plainly, poetry. No; I was wrong. It is not poetry, it is music. Counter-jumping Adonis of a Paolino, hero of measuring staff and scissors; Carolina, vulgar little shopkeeper's daughter— some curious metamorphose seems to be at work upon you. In that famous air, " Before Aurora appears in the heavens "

(no more is said about Aurora, but instead, a great deal about travelling carriages, whips, postillions), and in that duet where, with the tallow candle in one hand and the shabby portmanteau in the other, the young people prepare to slip out of the paternal house; in these, and in ever so many melodies and fragments of melody, there is something undefinable, something, strange to say, which makes the same impression as those phantasmagoric visions of *Mefistofele*; something that at bottom, is of identical natural, something we call music, and feel inclined to call poetry.

* * * * *

It really does seem at times as if there existed between us and the men of the late eighteenth century a perfect abyss; one wonders whether the series of human lives has really been uninterrupted. This is especially the case in all matters imaginative; for, as I have already remarked, those amiable great-grandfathers and great-grand-

mothers were possessed of little poetic fancy, or if they had it, contrived to put it successfully under a bushel. This reflection has arisen in my mind from a comparison between the subject of to-night's opera, the *Matrimonio Segreto*, and the opera of two days since, namely *Mefistofele*.

Yes, you will answer, but is not one of these comic and the other serious? Quite true, but this makes no difference. A comic piece can have as much poetry in it as a serious one (all Shakespeare's comedies, and Musset's, are there to prove it); and the eighteenth century was equally flat and unimaginative in both styles. Nay, it is odd that the most imaginative subject that ever fell into the hands of an eighteenth century composer, happened to be that of a comic opera, *Don Giovanni*, a tragi-comedy of savage and fantastic Spanish comicality, reduced to utter prose first by Moliere, then by Goldoni, and finally by Mozart's libretto writer, D'Aponte.

In short, I defy any one to show me an opera libretto of the eighteenth century which is imaginative in the same sense as *Mefistofele*. Metastasio's opera librettos have a poetic quality, dramatic interest, pathos, even grandeur; but they have nothing imaginative, although he hunted for subjects not merely in Plutarch and Herodotus (whose names he always put at the end of the "argument," learnedly contracted, with those of Sanchoniathon, Berosus, Ocellus Lucanus, like Dr. Primrose's friend, lest any one should think he did not work sufficiently hard for his salary of Court Poet), not merely in Plutarch and Herodotus, but also in Ariosto and Tasso. On the other hand, Gluck and his librettist Calsabigi, both of them furious reformers, pre-Wagnerian Wagnerists, were never struck with the idea, which every fifth-rate composer would have to-day, of using up in their opera the barbaric, fantastic, and gruesomely imaginative element contained in

the massacre of Orpheus by the frantic Maenads. Orpheus and Eurydice are sent home quietly, at the end of the third act, like a newly-married couple returning from their honeymoon.

All those good composers of the eighteenth century, from Carissimi, their precursor, to Rossini their latest representative, manufactured their music as other men manufacture soap or cloth (and much in the same way, I may add, as were manufactured also the cathedrals of the Middle Ages and the frescoes of the Renaissance), at so much a day. Sometimes they put into the business more conscience or more genius, and sometimes less; but they worked on, all of them, in the same happy unconsciousness of any imaginative suggestiveness. And when the public or the manager wished it, these great masters of delicate melody, of magisterial counterpoint (at least in their sacred music), were quite pleased to set afresh, once, twice, or even three times, the

same libretto, the same words, as they were quite willing (except for natural human laziness) also to overhaul or exchange the music written specially for some situation, because it did not suit their singers to sing those particular pieces.

What an abyss between a man like Boito and these musical bricklayers, tailors, cobblers of the last century! Nevertheless, we must believe Hegel, a sort of Council of Trent in all æsthetic matters, and who taught, what all professors of æsthetics are bound to teach, namely, that music is *the* romantic art above all others, that is to say the art where the concern for the subject, for the poetical suggestion, for what the Germans call *Inhalt*, entirely lords it over any concern for the mere form.

<p align="center">* * * * *</p>

"Canta Sirena — Canta Sirena" — this tune of *Mefistofele*, knocking about in my memory, suddenly comes in collision with the theme of the second finale of the

Matriomonio Segreto. This is indeed poetic and suggestive art, *romantic* art, this of Boito's. After all, Hegel doubtless knew what he was talking about. Poetic, romantic, suggestive — But suggestive of what? Of the siren, to be sure, and the full moon. But, after all, where is the siren? where is the full moon? In the words. As to the music, it would be difficult to point out in what particular arrangement of notes there is any allusion to a siren or a full moon; indeed it might be hard to convey either of these two items to the mind of the audience, if that audience happened not to understand the words.

What is more is that I have a similar difficulty in finding in the arrangement of notes which constitutes the second finale of the *Matrimonio Segreto* any indication of the marriage of a shop-boy and a shop-keeper's daughter, and of their consequent flight down the paternal stairs with a tallow candle in one hand and a portmanteau in the other;

still less any indication of the presence of papa, snoring unsuspectingly in bed. Nay, if some poet of my acquaintance would only be so obliging as to fit a couple of verses about sirens and full moons to the tune of this duet, I really see no reason why . . . No. The thought is odious. No self-respecting creature could assert that these notes, associated during ninety years with the difficulties of a shop-boy and a shop-keeper's daughter, with the tallow candle, the portmanteau, and the snoring of papa Geronimo, might, if only you clapped on a few verses about the siren and the full moon, serve equally in evoking the vision of that June moonlight when Helen of Troy and her women, moonbeams vaguely humanized, wander about among the Centaurs and Sphinxes, the Dryads and Nereids of the classic Walpurgis night.

* * * * *

In that case, wherein consists the poetry? Wherein lies that something ideal and super-

natural which we feel in Boito's opera, if that phantasmagoric vision of Heaven and Hell, of Antiquity and the Middle Ages, is not evoked by the music, but by the words? Wherein consists the poetry? The poetry of this opera, which treats of necromancers and angels and sirens, lies simply, to my mind, in the something wherein lies also the poetry of that other opera, dealing with deaf papas, flirtatious old spinsters, shop-boys, and runaway marriages: in a very prosaic circumstance—the fact that the music is beautiful.

After which very unpoetical and excessively unphilosophical remark, I had better banish from my mind the melodies both of Boito and of Cimarosa, and take down that volume of "Vorlesungen über die Æsthetik," in which Hegel demonstrates in the most satisfactory manner that music is the art where concern for the form is most completely subordinated to concern for the subject.

APOLLO THE FIDDLER.

A
CHAPTER ON ARTISTIC ANACHRONISM

APOLLO THE FIDDLER.

A CHAPTER ON ARTISTIC ANACHRONISM.

——:o:——

RAISE up and hollow out your two hands, so as to exclude from your eyes all the vague, flickering shadows; so as to concentrate what little light you can upon that luckless unlit fresco over the prison cell window of the Signature Room of the Vatican. At first we can see scarcely anything except the spots of light dancing before our eyes; but gradually the black wall seems to scoop itself out, to deepen, till the mass of blurs take shape, and becomes the ghost-haunted slopes of Parnassus. Vaguely still, and for ever sucked back into the darkness, flickers forth

the company of poets: bearded, regal men, with filleted, gem-like heads, and robed youths with laurel wreaths in their long hair; and the Muses seated with lyre and flute, in gowns of white and green and tawny red; and glimmering white in the midst of all, on the summit of the hill, beneath the straight-stemmed laurels, with the streams bubbling and the flowers opening between his naked feet, King Apollo, seated with his bow in his hand and his fiddle against his cheek. We look, and laugh, and ask ourselves why in the world Raphael should have chosen to paint Apollo as a fiddler? Why indeed? Well, I have a notion that I can explain to you why Raphael painted Apollo as a fiddler, and I will try and expound my idea; but on one condition, that afterwards, in return, we shall do our best to explain why, Apollo having been painted as a fiddler, that circumstance should have made you laugh.

Why Raphael painted Apollo playing,

not upon lyre or cithara, or any other imaginable antique instrument, but upon a fiddle—upon, of all things, the most modern, unantique of instruments, an instrument born of the Middle Ages, and raised to importance only in Raphael's own time—this is a question which has exercised the ingenuity of a variety of ingenious persons. Some have supposed that Raphael wished to indicate that Apollo was not only the god of poetry, but of music; and that he gave him, therefore, in contradistinction to the lyres and citharas and psalteries, instruments used solely to accompany lyrical declamation and therefore symbolical of poetry, handled by the Muses, the one instrument which seemed most purely musical, most disconnected with mere verse recitation—the violin. Others have imagined that the fiddle was placed in the hands of Apollo as a delicate or indelicate piece of favour-currying with some musical minion, some viol-playing page of Pope

Leo X.; perhaps even that same lad, with dark wistful face, and long straight hair, whose portrait Raphael painted, bow in hand, dressed in green velvet and fur. Others have put forward yet other explanations, with which we need not be troubled. Explanations of this sort people have felt bound to make, because the most obvious explanation of all—the explanation of the similar vagaries of Benozzo representing Babylon with Strozzi palaces and Chinese pagodas, of Pinturicchio painting Ulysses returning in the dress of a Sienese man-at-arms to a weaving Penelope apparelled like the lady of any Petrucci, Tolomei, or Piccolomini of his day; nay, of Uccello painting a chameleon as a monster half camel, half lion—the simple explanation of blissful ignorance, cannot go any length to explain the fiddling Apollo of Raphael.

For Raphael was of all men the least likely to be guilty of a sin of ignorance. He was, above any artist of his time, of

the literary, learned, or at least dilettante-learned, temperament. In the vague accounts we obtain of this rather pale-coloured and faintly-drawn man of genius, almost the sole strongly marked characteristic is the noble-patron-of-learning sort of interest, the refined, accomplished, scholarly-gentleman delight in antiquities. It is true that many other artists of the Renaissance had as great, if not greater, a passion for antiques as Raphael, but none, it would seem, from the same reasons. For them the antique was a mere subject of study. If Mantegna spent fortunes, and sold houses and orchards, in order to buy mutilated statues and battered bas-reliefs and half-obliterated coins; it was that to the intense, fantastic master of Mantua these things were as the ores and smelting-ovens of an alchemist. It was that he sought, in the broken, rust-stained marbles, what Leonardo sought in fanciful geometrical problems, and Michael Angelo in dead limbs and

flayed bodies—a sort of magic, omnipotent spell, a sort of ineffable elixir of life—the secret of perfect proportion. But it was not so with Raphael: a student of Tuscan nudities, a dexterous imitator of Michael Angelo, he was yet at bottom an Umbrian, bred in the workshop, the manufactory of disembodied yearning saints, of Perugino; and the antique, although he studied it as he studied everything else, was never to Raphael a supreme teacher or a final problem. His love for all things antique, his constant alacrity to buy or have copied any ancient marbles that came within reach, his anxiety for the preservation of the ancient buildings of Rome, all this was merely the result of a sort of humanistic tendency, a sort of intellectual busybodyness, seeking for a vent in a man of far less literary training than many of his contemporary artists; an interest, in short, academic and archæological, in antiquities for their own sake, such as was shared by his nobler and

more learned friends, Bembo and Castiglione and Sadoleto and Fedra Inghirami, and in less degree by all the poeticules and prelatry of the court of Leo X. Raphael, therefore, cannot be supposed to have been ignorant of the antique instruments which might be placed in the hands of Apollo; nor to have been ignorant (at least for any length of time) of the fact that the fiddle was not an antique instrument. He, who certainly took a vast deal of scholarly advice for his Vatican frescos, who must have heard whole lectures on antique philosophy and poetry before he was able to compose The School of Athens and Mount Parnassus, could not have put a fiddle into the hands of Apollo from the mere stolid ignorance, the happy-go-lucky indifference, which made both Signorelli and an unknown pupil of Squarcione coolly sketch, the one an Apollo, the other an Orpheus, fiddling away in the face of all archæology.

If, therefore, an anachronism was com-

mitted by Raphael, by the preeminently archæological painter, it was certainly not without a motive. No, not exactly a motive, for a motive is self-conscious, and consciously restricted to one particular case. Rather a habit, unconscious and general, influencing in one case because it influenced in all cases. Raphael gave a fiddle to Apollo, not because the giving of the fiddle had any particular meaning in his eyes, but because the giving of the fiddle was consonant with the manner of conceiving subjects which Raphael shared with all the painters of his day; which the painters of his day shared with all the men and women of the Renaissance; and which the men and women of the Renaissance shared with the men and women of ancient Greece, of the Middle Ages, of Elizabethan England, of every country and every time which has possessed a really great and vigorous art— sculpture, painting, poetry, or music: the habit of conceiving of all subjects given to

the artist as the mere material or pretext for a decoration, a show, a pageant; a pageant of sculptured or painted forms, of grouped and linked sounds, of images and emotions; a pageant to pass before the mind, ostensibly to tell some story or honour some person, really merely to delight, even as some great mystery play, with its processions of richly apparelled and grandly mounted soldiers, its cavalcades of mummers and musicians, its companies of singing choristers, its flower-wreathed poles and painted banners and flaring torches, its wheeled stages hung with arras and cressets, and peopled with strangely arrayed figures, may have passed, to do honour to some prince, or to enforce some religious lesson, slowly through the streets of a mediæval city.

To us such a conception of artistic subjects seems far-fetched, artificial, nay, almost impossible; yet it is in reality by far the earlier, the more natural, the more really

artistic. The desire for realizing an already known event, for imitating an already extant character, for placing before the imagination a fac-simile of something existing outside it, or for showing to the bodily eyes what was visible already to the memory; this desire for pitting together the artificial and the natural is, in point of fact, one of very late growth. It did not exist as long as events and characters seemed sufficiently interesting from their more practical bearing; as long as the past was too active a factor in the present and future to require any further reason for remembrance. It could not exist as long as artistic means were fully employed in satisfying men's fancy or expressing men's cravings; it could not exist as long as the artificial and the real were both sufficiently important to dispense with the interest due to comparison between them; nay, such comparison between the reality and the artistic representation required a lazy and

objectless activity of the reason, which was impossible in a time when the reason, overburdened with practical problems, had little leisure for play, and when the artistic cravings and activities were too rigorous to be its passive playthings. Above all, the purely intellectual reasoning enjoyment of watching how far art will differ from nature could not exist as long as the mechanical powers, the powers of responding to the artistic wants of mankind, were still growing in their constant efforts after the yet unaccomplished.

There is in all the art of great periods a sad absence of logic; at least of the logic which we expect. Mere chronicle and mere portraiture put aside, the exposition of an event or of a character is generally embedded in a perfect arabesque of poetical or pictorial digressions. In a play, which is, after all, only the imitation of the manner in which we suppose any given events to have taken place, there is in Antiquity

a series of musical and lyrical interruptions, a series of odes upon extremely indifferent subjects sung at the most critical moments by people who would either not be present, or be thinking of anything rather than choruses; there is in the Elizabethan period a constant arabesquing off into most elaborate lyrical imagery, of digressing into complete chapters of philosophy; all things which we disregard from a sort of inherited familiarity with the style, but which would astonish us greatly if we had never before read anything like "Prometheus Bound" or "Macbeth"; astonish and shock us as much as some intelligent child or peasant would be astonished and shocked by the orchestral preludes, the roulades, the fugues accompanying the conspiracies and murders of our opera stage. Indeed, an opera, with its symphonies, its airs, its quintets and sextets, its choruses, its ballets, its whole tissue of unrealities woven over a few threads of realism, is perhaps the only

artistic form of our day in which we can study the unrealistic, pageant-like art of past times; the only modern thing which can make us realize, with its innumerable incongruities and impossibilities, endured for the sake of mere artistic pleasure, the sort of serious masquerade, the solemn mummery of the plastic and poetic art of former days.

People did not ask for realization; they did not ask to be shown an artistic facsimile of a character or of an event. The public which crowded Blackfriars or the Globe Theatre did not ask for a realization of a tyrant as Becky Sharp is the realization of an adventuress; they did not ask for a realization of a tale of murder as any novel of Emile Gaboriau is its realization: they merely wished to be interested and delighted; and a certain proportion of rough psychologic portraiture, a certain proportion of loosely narrated story, a certain amount of passionate expression, of philo-

sophic rhetoric, of poetic magnificence, of trap-door and magic-lantern horror, did succeed in interesting and delighting them: and the whole strange compound of developed and half-developed elements was called, as the case might be, Macbeth, Hamlet, or the Duchess of Malfy. And the same with painting. The most subtle Florentine public did not ask for a realization of a Scripture story, or an episode in history, as Alma Tadema's "Ave Cæsar," or Morelli's "Raising of Jairus's Daughter," may be considered as realizations of events, as representations of men and women, and place and costume, and look and gesture— of the whole occurrence, in short, such as it probably looked. They were satisfied, the people of the Renaissance, with a figure or two which they could recognize as St. Peter, or St. Paul, or the Proconsul, or the priest of Apollo, with the traditional costume belonging to them, the general expression of exhortation or prayer, or

command or terror, which might convey to their mind some idea of their action; and then they were satisfied that Masaccio or Filippino or Ghirlandaio should surround the whole scene of altercation or of miracle with a group of Greek soldiers, of mediæval men-at-arms, of robed scholars and magistrates, of ladies in brocaded stomachers, and nymphs in antique draperies, of pretty dandies in kilted tunics and striped hose, of people with baskets, and dogs and horses and musical instruments, all looking in no particular direction, with plenty of vine trellises, perspectived streets, peacocks, bas-reliefs or imitation dolmens, with arches of rock overgrown with trees and framing views of towered towns in the distance.

Was it stupidity on the part of the men for whom Shakespeare wrote, of the men for whom Masaccio, or Botticelli, or Signorelli painted? I should not care to tax them with that; or if it were, their stupidity had better results than our wisdom.

I do not think that they had all these things done from mere ignorance or dulness. I think they had merely a different system, a different habit of viewing artistic matters. They did not require that all the items of play or picture should be portions of an organic logical growth, that each part should depend upon another, and the whole produce a single logical impression, any more than, when you make a nosegay or garland, you expect all the flowers and leaves to be homogeneous: lilies do not grow on melon plants, nor poppies on oak leaves; yet as a combination of form and colour, as a decoration, a garland such as the Robbias were wont to imitate in their altar-pieces is certainly preferable to a garland made all of one flower, or of one sort of flower. I have said "as a decoration," and this brings me to the fact that the art of all great periods is, in point of fact, nothing but a decoration; for just as men made their dwellings delightful by stamping

leather with blue and gold patterns (which are certainly not what leather naturally presents) and hanging it on the walls; by weaving the dyed threads of wool and silk into strange figures and devices; by cutting holes into wood and filling them up with bits of ivory or mother-of-pearl; by setting together all manner of various marbles in shapes such as no quarry could ever show; by carving in wood, and painting on plaster, all sorts of shapes, just like enough to beasts and flowers to show that there never was beast or flower like them: as men united together things and forms from all parts of the world and all orders of creation, and altered and assorted them to beautify their houses; so also men took elements of thought and feeling and form, things which delighted the eye, and things which appealed to the fancy, and united them together into quaint and gorgeous arabesques, with which they patterned their lives. And if we consider for a moment, and put aside

all our own habits of considering art as a semi-scientific product, we shall acknowledge how much more natural and spontaneous is such arabesque of form and fancy than our own modern attempt to adorn, to decorate our lives with the museum cases, the rows of pricked and pinned butterflies, and stuffed animals of psychological analysis; to stencil it over with the tables of dates and geological maps of logical realism; whence it is that our lives, for all the attempts we make to adorn them, preserve to the last so dreary a look of schoolrooms and laboratories. Thus we must understand that in the art of the past there is no more logical homogeneousness than in the arabesques of a carved chest or a painted plate; things are juxtaposed and combined with reference only to pleasantness of effect. Hence it is that we constantly meet in the paintings of the Renaissance, and even of the Middle Ages, what appear to us contradictions in

the telling of a story, jumbles of time and place, broken up or hopelessly muddled allegory. But in reality only a fragment of story was expected to be told, only a small amount of unity of time and place to be observed, only a scrap of allegory to be carried through; what seems to us the contradiction, the jumble in story or allegory, no longer belongs to the story or the allegory; is something else, possibly as foreign to them as the miniature angels along the gilded border, or the griffons and satyrs upon the carved frame. These things were not intended to logically coalesce, they merely pictorially harmonized. The gentlemen in furred robes and ladies in high coifs, who knelt at the foot of the cross, the pages holding the caparisoned horses, and the half-naked St. Johns and red-hatted St. Jeromes of Van Eyck's and Memling's pictures were not supposed to be really co-existing with the fainting Virgin, the sobbing Magdalen, the bleeding

Redeemer; the cross was not really supposed to be erected in front of a Dutch castle farmhouse, with fowls cackling by its barn door, palfreys crossing its drawbridges, and ducks swimming in its moat. All this was neither narrative, nor representation, nor allegory, but a little of each and all, combined into one beautiful-looking picture, into one confused, suggestive, moving, delighting pageant of the imagination. For the agony on the cross, the anguish of the Virgin and her attendants, touched people's hearts; the knights and ladies and horses impressed their imagination; the barn-door, the drawbridge, the ducks, the rabbits, the twenty familiar irrelevant details, tickled their fancy; the singing angels sounded delightful; and the whole—to us so incongruous—picture was enjoyed like some great play, in which there is tragedy and comedy, and pastoral and allegory, all mixed together, and the whole effect of which is delightful.

Such, therefore, was the spirit in which even that strangely modern-minded, reasoning, psychological, archæological Raphael must have conceived his works. And in this lies the explanation of that anomaly of the fiddling Apollo. It is difficult to indicate, with however much sense of their unconsciousness and vagueness, the vague, unconscious thoughts and feeling which form the background of all conscious artistic creations. As soon as ever we speak of them they appear definite, conscious; they are no longer the real thing. We can therefore only vaguely suggest the sort of confused conception which Raphael may have had of his Parnassus. In the first place, and of entirely overbalancing importance, the sense of a great piece of pictorial composition,—of perspective, drawing, colour, and so forth; then the sense of an allegory of poetry, of personified abstractions; then, again, the sense of certain individuals, of certain personalities—these

two purely intellectual conceptions very much mixed up and entirely driven into the shade, or, more properly speaking, absorbed into the all-important pictorial conception. Thus there would come to be a similar confusion in the conception of the details of the work. There would be an idea of Apollo—of an antique personality, an individual belonging to a definite period of time; then an idea of poetry personified, of poetry in general, modern as well as ancient, not belonging at all to any particular epoch; then again of music, and of music in all probability as something modern—the music which Raphael had heard, not the music which he had not heard. A nebulous, eddying sort of jumble, united, solidified, cast into definite shape by the predominant thought of a young man, a naked young man, a model—yes, seated thus, with his arm thus. The real lad, peasant or colour-grinder, the real, distinct form, fills the mind of Raphael;

he takes a piece of paper and rapidly scrawls a figure, the figure of the boy whom he sees in his memory, whom he sees perhaps as a present reality; quick, the outline of his swaying body, of his firmly planted legs, of his upturned, sidelong face; and then—who shall tell how? —from the subsidiary conceptions of the work, from the intellectual notions of his meaning, come his surroundings — the roughly sketched Muses, in antique draperies, belonging to the idea of him as Apollo, as the antique reality; the rapidly indicated figures of the poets—of Father Allighieri and Messer Francesco Petrarca, and perhaps even of Messer Piero Aretino —as part and parcel of the idea of poetry, of poetry in general, old and new, embodied in this youth; and finally, as a recollection of the something musical which enters into the vague whole, there comes into Raphael's head, and emerges from under his pencil, with some recently heard tune starting

suddenly into his memory, the final touch—the fiddle.

So the work is done: the anachronism is committed; yet without either unconsciousness of its being an anachronism, or consciousness of its being one; without either ignorance or absurdity. And when the men of the Renaissance, the prelates and courtiers, the humanists and antiquaries, come and look upon the work, they do not laugh, they do not ask the meaning, they do not question about anything. For in their minds exists the same decorative arabesque as in that of Raphael. An antique god, a personified art, a remembered tune, a bit of narrative of how King Apollo was wont to sit upon Parnassus; a bit of allegory of poets grouped according to their styles and merits, in company with the personified branches of the art; a bit of realism, a recollection of heard music, a fiddle—ideas running confusedly into each other, pleasing, amusing, reminding; above

all, a noble piece of work, a noble group, grandly perspectived, nobly drawn, harmoniously coloured.

But it is different with us; with us who understand so much about all the conditions under which art was produced, and who sympathize with them so little. We come into that prison-like hall of the Signature, we blink and wink in the half-light, we screen our eyes from the shadows, till the frescoed Parnassus gradually emerges from out of the dark wall. We look, appreciate, admire, enjoy (or think we enjoy), and then we laugh. At what? At Apollo, or at his fiddle? Surely not at Apollo. He is but a single figure, very simple and simply worked, not elaborate either in form or in expression, yet perhaps conveying a greater impression of genius than all the dozens of Madonnas, Perugine and Florentine and Roman, than all the great ceremonious allegories like the "School of Athens" and the "Dispute of

the Sacrament," than all the Michangelesque nudities of the "Burning of the Borgo," with that terrible perfection of drawing and composition and expression, that terrible balance of good qualities, pictorial and psychological, which so often makes Raphael less interesting than many a one-sided, unintelligent little Lombard, or Umbrian, or Venetian. He is but a simple, human-looking god, yet perhaps more poetical, and poetically charming, with his slightly raised young head, singing, quite gently and *sotto voce* as yet, humming over the song he has just composed and will sing anon quite loud and joyous to the Muses—more poetically charming, perhaps, this fiddling Apollo of Parnassus, than almost any marble Apollo of antiquity; than the little Lizard-hunter, a lithe and supple young lizard himself, of Praxiteles; than the young Florentine Apollino, the delicate poet-boy, with hair dressed by some admiring Muse; than the long-robed

laurel-crowned Musagetes of fluttering, half-theatrical inspiration, the divinization of the *improvvisatore*, of the male or semi-masculine Corinne; than the sombre prophetic Pythian (Cassandra's ill-omened lover, certainly) leaning his half-draped chest upon his cithara, wearily pillowing his braided head upon his arm; nay, even than the wizard statue of the Belvedere, which, for all our wiser judgment, for all our archæology and all our knowledge of Elgin marbles, does still give us a little shock of surprise, a little shudder of delight, every time that we, the contemptuous moderns, come face to face with him. No, certainly, we cannot be laughing at Raphael's Apollo. Is it then at the fiddle? But why laugh at the fiddle? There is nothing absurd in a fiddle. If the good Saxon name shock you, call it, if you will, poetically, viol; or musically, violin, tenor, alto—according to the pitch you judge it to have. To the eye the instrument handled by Apollo,

though lacking the subtle curve, the sharp scooped flank of the perfected fiddle of Amati, or Guarneri, or Stradivari, is even in its pre-Cremonese ungainliness more elegant in shape, and much more graceful of manipulation, above all, infinitely finer in tone than any lumbering antique stringed thing. To the imagination, on the other hand, it does not, or need not, present any grotesque images. There is nothing grotesque in the recollection of one of Haydn's quartets or one of Tartini's sonatas; nothing undignified or unpoetical surely in the thought that just such an instrument as this once rested against the moonlit armour, and whined beneath the reddened fingers of Volker the Fiddleman, as he sat with Hagen of Tronegg on the bench outside Queen Chriemhilt's hall, holding watch over the dreadful chamber where Huns and Burgundians lay slaughtered beneath the charred and fallen rafters; nothing unpoetic in the thought that just

such an instrument as this is played on the carpeted steps of the Venetian altar-pieces by the angels at the feet of the Virgin, enthroned in solemn drapery of wine-lee and clove crimson in her tapestried niche, beneath the dangling silver lamps and the garlands of melons and lilies and green leaves slung in heavy festoons. You do not laugh at the fiddle of Morone or Bellini's angels; you do not laugh at the fiddle of the Niebelung knight; you do not laugh at the fiddle for which Hadyn or Mozart composed. Why then laugh at this fiddling Apollo of Raphael's? In reality we are laughing neither at Apollo nor at the fiddle, but at the anachronism, the anomaly of their being thus united— the antique god and the mediæval play-work. We are laughing at the mere name, the droll meeting of incongruous words, "Apollo the Fiddler." And as the name sinks into our mind there crowds forward a vague jumble of grotesque ideas—of

Heinrich Heine's tales of exiled gods, of Bacchus turned convent cellarer, and Jove selling rabbit-skins on Heligoland, and Mercury turned Dutch skipper, with pigtail instead of winged cap, and knobbed cane instead of Caduceus. Apollo the Fiddler! and there emerges from out of this confusion a vision of Apollo wandering from fair to fair, and from pothouse to pothouse, with his fiddle on his back; of Apollo screwing his pegs and waxing his bow among the clatter of plates and glasses, the cries of water-melon and pumpkin-seed sellers, the gabble of pedlars over their tapes and fans and mirrors, the shuffle and scramble and hum and yell of a village holiday; the vision of the god seated calmly, with dangling legs, on the side of some wooden stage, fiddling away in concert with earthly pipers and drummers until the curtain shall be drawn aside from some mystery play of "Joseph and his Brethren," or "The Three Kings from

the East;" from some grand display of giantesses, or painted negroes, or camels bestridden by wrinkled, red-jerkined monkeys. Why should we be thus haunted by grotesque images? why should we laugh where the men of the Renaissance merely enjoyed? Those humanists surely knew as well as we do what were and were not antique instruments; those men for whom the greatest art was produced surely knew as well as we do what was artistically right and what artistically wrong. Yet we laugh, and they did not. For, as we have already seen, those men did not let their knowledge of how things are or have been in reality, interfere with their enjoyment of how things are represented in art; they designed ornaments where we only label specimens; they did not habitually and perpetually, almost unconsciously and automatically, judge of all things from a scientific point of view.

From a scientific point of view? This

assertion takes you somewhat aback, does it not, my friend? You, at least, you imagined, were safe from such an imputation. For you happen to be peculiarly unscientific, particularly artistic. You are (and not without a little pride thereat in your heart of hearts) a person whose artistic and imaginative nature is for ever being ruffled by the scientific spirit of the age. You hate all explanation, analysis; you recoil, almost as from some gritty or clammy contact, from the theories which attempt to explain your likings and dislikings; you are, even by your own confession, just a trifle cowardly in the presence of ideas and facts; you wish merely to feel and imagine, and to keep the luxurious sense of mystery and wonder. You are proudly conscious that your real home was not modern London, but ancient Athens or mediæval Florence; and being thus cruelly exiled into a land of desolation, you strive to build out of all manner of frag-

ments of beauty and fancy, and fashion, out of all manner of broken-down, long-inherited sounds and sights and images, some sort of retreat, half hermitage, half-pleasure dome, where your soul can loll at its ease, secluded, peaceful, high above the smoke and smut and rattle of modern ideas. You have, in short, a vague, uncomfortable, instinctive aversion to science. And yet you, even you, are in this case, and in a thousand similar cases, judging and even condemning art from the point of view of science.

When we say science, we must define. There is science of all kinds, and some kinds have no possible chance of intruding into the domain of art. And, strange to say, these latter happen to be the very sciences you dislike most: those physical sciences, physiology, optics, acoustics, which teach other folk (for you decline being taught) why certain linear forms by requiring a painful adjustment of the visual

muscles, and certain colour combinations by causing an excess of stimulus to the retinal nerves, and certain sequences and meetings of sounds by disintegrating with opposed movements the delicate mechanism of hearing, give us, each in its way, an impression called ugliness; while certain other combinations of lines, of colours, and of sounds, induce the pleasurable sense of beauty: these natural sciences, which thus impertinently and coarsely explain the causes of artistic likings, do not attempt to influence those likings and dislikings themselves. For art deals only with the very surface of Nature; with that which she reveals to the naked eye and the unaided ear, with the combinations which require for their perception neither scalpel nor alembic nor logical mechanism of analysis. Our artistic sense of right and wrong is safely based in the structure of our organism, which science may explain, but which science cannot replace. It is

from no knowledge of cell or tissue, of bone or muscle, of anything inside the human body, that we know when that body is comely and when it is uncouth. Our perception of line and colour, perhaps a collateral sense of weight and resistance, perhaps even a long engrained, long unanalytic, long instinctive, nay, automatic sense of fitness for the purposes of life— all these various senses, combined into what we call artistic perception, taught the Greek sculptors where to seek models for Aphrodite or Apollo long before the first profane knife had ever pried into the mysteries hidden beneath the mere grand curves, the supple broken lines, the beautiful surface of the human body. Knowledge of beauty, knowledge of the fair shapes and tints of man, and beasts, and plants, and rocks, and skies; knowledge of the sweet harmonies or melodies to be got out of pipe, or string, or throat—knowledge of beauty, though knowledge, most indis-

putably, is no more scientific knowledge than is the knowledge of virtue or vice. Science, with its analysis, can teach us what hidden reasons of physical benefit or injury, of social progress or degradation, have made us such as to prefer beauty to ugliness, good to evil; but science was not born when our remotest ancestors already preferred beauty to ugliness, good to evil, and thought that the preference, the knowledge, was the pressure of some guiding angel's hand, the mysterious voice of some unseen divinity. This sort of science, therefore, physical and physico-mental, which explains the functions by the structure and the structure by the function of things, has therefore no power of meddling with art; for the sculptor knows before the anatomist when a limb is misshapen; and the musician has perceived that a chord is insupportable long before the physicist can begin analyzing his air waves.

No; it is not those coarse matter-of-fact physical sciences which can and do impertinently interfere with art. It is those far vaguer, less scientific sciences, historical and geographical, which with their charm of colour and incident, their stimulus to fancy and emotion, have become one of the luxuries of your life, making you forget almost that they are sciences at all; as in some picturesque museum, where furniture and plate are grouped into habitable rooms, and armour and musical instruments look as if only now thrown aside; or in some great greenhouse, where spreading palms and huge ferns hide the glass and ironwork, and flowering parasites half impede the way, you may forget that all these things are so many scientific spoils, so many specimens collected and arranged by historian or geographer.

These geographic and historic sciences, which you look upon as if they were scarcely sciences at all, have in reality no connection

whatever with our perceptions of beauty and ugliness; their range of explanation does not contain any of the phenomena of artistic preference. As the physical sciences explain the structural reasons of our pleasure or displeasure at certain artistic forms, so the geographico-historical sciences explain why given countries and ages have produced one kind of artistic form rather than another. The one set of sciences explains the impression being received by the spectator; the other set of sciences explains that impression being conveyed by the artist. But the geographico-historical sciences, which teach us that the Greeks modelled beautiful naked figures because they greatly practised athletic exercises; and that the Venetians were excellent colourists because they lived in sea-marsh land and traded with the East; these geographico-historic sciences approach less near to the real artistic problems of right and wrong than do those physical sciences that teach us, that owing to

the configuration of our eye, the bosses of Greek sculpture and the tints of Venetian draperies are specially agreeable to us. Yet, while physiology, optics, acoustics, never venture upon interfering in our artistic judgments; the geographico-historical sciences, which cannot even explain the physical basis of our artistic impressions, are for ever stepping in and telling us that in a picture, a statue, or an opera, this, that, or the other is right or wrong. Nay, it is they, these irrelevant sciences of date and place, which, while our artistic preceptions are perfectly delighted, will cry out that we ought to condemn some anachronism; it is they which, in the midst of our admiration for Raphael's Parnassus, evoke that whole procession of ludicrous images, and burst out laughing at the Fiddling Apollo.

Yes; and they have made us laugh at many other things. At Mozart and Rossini's Romans and Assyrians singing roulades and declaiming accompanied by or-

chestral flourishes, like so many Corydons and Chloes, in the Forum or at Nineveh; they will make us laugh at half the paintings of the Renaissance; they may make us laugh some day at Shakespeare's jumble of Athenian dukes and London tradesmen and fairy-land fairies. The laughing is, however, the least harm they have done; for, after all, when we have laughed at Raphael or Mozart or Shakespeare, we are still obliged to enjoy and to admire. We are not smitten blind or deaf for our sacrilege; and the great artists are avenged by our ignominiously returning to the very things we scorned. But our scientific habits, our habits of always knowing how and when and where everything happened, have made us believe that it is a special mission of modern art to make up for the anachronisms and anomalies of former days by becoming in a way the illustrator, with colours, sounds, and words, of the reality of things as we now suppose it to have been. His-

torical painting, which in former days had nothing whatever to do with history, and calmly presented us with Romans and Egyptians and Hebrews in slashed jerkins and pointed shoes, has in our time become historical in all good sooth; poetry, which used to put into the hearts and mouths of men and women of distant countries and bygone ages the passions and words of the poet and his own contemporaries, now elaborates and studies and imitates sentiments which we fortunately can no longer even conceive, words of which the real sense has happily grown obsolete to us. Nay, music, which would seem the most ungeographic and unhistorical of all arts, has succeeded, as critics tell us, in giving us " historic opera;" and even, as an enthusiastic Frenchman declared about the " Aïda " of Verdi, in delighting us no longer with mere empty melodies and harmonies, but with the vision of ancient Egypt, with its pyramids and mummies, its priests and its warriors, its

desert sand and Nile mud, and all the mysteries of its mixed mysterious races. All this may seem exaggeration, and indeed, when such aims and pretensions are distinctly formulated, there are few of us in whom they will not occasion a smile. Yet in point of fact we are constantly acting and judging according to these ideas; painters turn their studios into perfect museums, and wander all over Syria and Egypt before attempting some subject which to Michael Angelo or Leonardo would have presented nothing beyond a problem of anatomy or of light and shade. Musicians collect and print huge volumes of the rude chants of distant peoples and times, in order that composers, when on the point of writing an opera, may know exactly where to look for the proper local colour. And as to poets—have they not turned of late into perfect rhymed Michelets and Froudes, requiring for their proper criticism no longer literary critics, but keepers of State Records?

What harm is there in all this? you may ask. Granting its uselessness, is it not a mere amusing mania? Not so; and for several reasons. First, because art must suffer in its essentials as soon as it is made subservient to some extra-artistic interest; because all this elaborate doing of things scientific prevents the simple doing of things artistic. For when a painter, well versed in Oriental realities, has made of what some ignoramus of Florence or Venice or Antwerp would have made into a grand display of beautiful figures, faces, and draperies, a something closely resembling, in its rows of flopping, veil-muffled, and shawl-huddled Egyptians or Syrians, a number of clothes bags in process of being emptied, the art of painting and the æsthetical cravings of mankind are not very much the gainers thereby. When a musician introduces into an opera elaborate imitations of the music of centuries and peoples who had no real music at all, his work is not much improved

thereby. Worst of all, when a poet has reproduced effects, modes of thought and feeling, he has not only given us things with which neither he nor his reader can sympathise, but he has at the same time cheated us of the expression of his own and our real emotions, which, in their quivering reality, can force the sympathy even of men to whom these emotions may have grown obsolete and strange. But this is not all: in thus attempting to make art the mere illustrator of science, we shall in the first place violate the inherent organic conditions of art; and then, as sole reward, give it, in exchange for the stability and imperishableness of artistic form, the fluctuating, changing impersonality of scientific fact. For, with regard to the nature of art itself, we must remember, or understand, what daily observation ought long since to have impressed upon us, that there is as complete an organic necessity in the sequence of style upon style and form upon form as

there is in the sequence of the seasons of the year and their respective products, or in the growth of the child into the youth and the youth into the man; and that thus all spontaneous, really vital and valuable art must always present a certain homogeneousness of form and character, a certain limitation in its capacities, which prevents the adoption of the forms and characters of another time or another place: for art, to be good, or rather when art is good—that is to say, when art is vital—men can imagine, write, paint, only the things which they see and feel, men can work only in the style which belongs to their race and to their generation: to ask, therefore, for a correct expression or imitation of feelings, fancies, or forms of other races and other generations, is simply to demand what no art in its vital condition, in its condition of really valuable function, can by any possibility give. And could living art thus become the scientific reproducer of efforts,

feelings, and forms, could any art worthy of the name exchange its own powers of satisfying our æsthetic wants, for the power of bringing home to us some scientific fact, some conception of distant or long-ended things; could it do this, what would be its reward? We have spoken of the stability and imperishableness of artistic form as contrasted with the fluctuating, changing impersonality of scientific fact: this phrase may have seemed to some an impertinence, to others an absurdity. Yet if we look into matters, we shall have to confess the truth (a bitter truth to the mere critic) that no purely scientific works can ever live, that no purely scientific book can ever continue to be read, that only artistic excellence endures.

For the man of science, be he naturalist or ethnologist or metaphysician, gives only a certain number of new facts, or a certain magnitude of new system; his successor inherits those facts and that system—increases

the one, enlarges the other; so that the second comer is always the richer and more valuable than the first, and the third than the second. The most valuable scientific book is necessarily the most recent, because it contains all the truth contained in its predecessors, and more, and also less error. The books of the very greatest scientific minds of the past are now read only by specialists studying the development of some particular science or idea. Harvey discovered the circulation of the blood, Newton gravitation, Smith the relations between price and supply and demand. Nothing can diminish their glory for having discovered those facts, but those facts no longer belong exclusively to them : they have been developed, corrected by others, and can be found elsewhere than in their books, and found more complete than in them. We venerate these men, but we do not read their books. If we want to know about gravitation, or about supply and demand, we turn, not to the " Prin-

cipia" or to the "Wealth of Nations," but to the most recent text-book of physics or political economy by some living mediocrity. The same fate awaits Helmholtz, Darwin, Spencer, Huxley, and all the discoverers of facts or laws. We all talk of Descartes, yet how wretchedly poor does not his great book appear to us! mere truisms which we knew before we were born. The same applies to Vico, to Montesquieu, to all those who have revolutionized thought. The man who made the very first plough was certainly one of the most ingenious of mortals, yet who would care to use such an instrument? and who would care to employ Stephenson's first railway engine, or Arkwright's first loom? Yet their makers were men of genius, while the makers of the latest, most desirable improvements in engines and looms may be mere craftsmen. Now the case is immediately changed as soon as the place of the relative elements, truth and usefulness, is taken by the positive

element beauty. For a truth is assimilated and grows, an invention is assimilated and grows; but a work of art, when once beauty has been attained, does not grow. You may repeat and re-repeat, and alter and re-alter it; you may destroy it, but you cannot develop it: its value is positive; time passes, and it is as delightful to the man of the nineteenth century as it was to the man of the fifth century before Christ. If you would benefit by what was done by Homer, by Shakespeare, by Phidias, Michael Angelo, or Mozart, you must have recourse to themselves. No addition can be made to their works; and it is noteworthy that the only books which are permanently reprinted are books of mere *belles-lettres*, which may be four thousand years old; the only objects which are constantly being copied, without attempt at alteration, are not useful mechanisms, but works of art. You may take a plaster cast of a statue of the time of Pericles; but who would care

to have an exact fac-simile of a revolver made twenty years ago? If scientific works continue to be read, it is because the element of eternity, the element of beauty, has entered into them; the scientific ideas may be old, but the artistic forms are not. We may know more of philosophy than Plato, or Bacon, or Pascal, but we have not got the power of writing as they did. And if any modern historian or philosopher be read two hundred years hence, it will be not as a man of science, but as an artist. A consolation this, and a great one, for nowadays much of what artistic instinct remains is taking refuge in critical writing. Our men of thought and research, Ruskin, Michelet, Carlyle, will be known as great artists to future generations, which will have let the memory of many of our artists die out as that of mere obsolete and mistaken men of science.

We have wandered a good way from our original starting-point, and some of you

may ask, What has all this to do with Raphael's Apollo? We started with asking ourselves how it came about that a learned man like Raphael, an artist above all his contemporaries, studious, thoughtful, nay, archæological, should have deliberately committed the anachronism of placing a fiddle in the hands of Apollo. We found that, in so doing, Raphael had merely followed the habit of his time, which considered artistic representation in a manner quite different from ours. And, proceeding to examine our own manner of viewing art and its functions, we found that, on the whole, the old way, which at first seemed to us so childish, illogical, and far-fetched, was simpler, more natural, and more efficacious than our own; that perhaps the illogical men of the Renaissance had more sense of artistic logic, of the logic of keeping everything to its right place and work, than we have; and that there is more anomaly in painting archæological pictures, writing

historical tragedies, and composing geographical operas, than there was in showing Apollo among the Muses and Poets, fiddling away on the summit of Parnassus.

UNWIN BROTHERS,

THE GRESHAM PRESS,

CHILWORTH AND LONDON.

www.ingramcontent.com/pod-product-compliance
Lightning Source LLC
Chambersburg PA
CBHW080653190526
45169CB00006B/2103